PRES
TEC

HOW TO SEL
BY

PRESENTATION TECHNIQUES

TECHNIQUES

FOR THE GRAPHIC ARTIST

HOW TO SELL YOUR IDEAS EFFECTIVELY

BY JENNY MULHERIN

PHAIDON · OXFORD

A QUARTO BOOK

Published by Phaidon Press Limited
Musterlin House
Jordan Hill Road
Oxford OX2 8DP.

First published in Great Britain in 1988
Copyright © 1987 Quarto Publishing plc

Reprinted 1989
ISBN 0 7148 2488 7

A CIP catalogue record for this book is available from the British Library

This book was designed and produced by
Quarto Publishing plc
The Old Brewery, 6 Blundell Street
London N7 9BH

Senior Editor Maria Pal
Art Editors Ursula Dawson, Rita Wuethrich

Editors John Clark, Ursula Wulfekamp
Technical Consultant Christopher Lumgair

Designer Peter Bridgewater

Picture Researcher Penny Grant

Art Director Moira Clinch
Editorial Director Carolyn King

Typeset by Comproom Ltd, London and
Central Southern Typesetters, Eastbourne
Manufactured in Hong Kong by Regent Publishing
Services Ltd
Printed by Leefung-Asco Printers Ltd, Hong Kong

Special thanks to Jack Buchan

CONTENTS

INTRODUCTION

■ **Right** The initial concept for some travel information packs was liked sufficiently by the client to be taken to a more highly-finished rough, with few changes made before the job was finally printed.

IN THE COMPETITIVE WORLD of graphic design, it is not enough merely to have confidence in your skills and ability: you must impress potential clients that you are not only good, but also the right person for the job they want to commission. This means that you need to know how to sell yourself or your company with enough flair to gain the client's confidence – and more specifically to maintain that confidence through the presentation of appropriate ideas and visuals for a particular job. Only after your ideas are accepted – the result usually of a number of presentations to the client – can you start work on the final product.

Oddly, the specific skills and techniques needed for presentation visuals have been somewhat overlooked by teachers and other experts in the field – largely because it is assumed, erroneously, that the skills required for graphic design are the same as those that 'sell' design ideas. Yet the fact is that however original and brilliant a design, it will fail unless it is presented to the client in an attractive, well thought out way.

This book redresses that imbalance. It shows you how to present design ideas with maximum clarity and efficiency. It takes you through presentation stages from rudimentary to highly finished roughs and outlines the techniques needed, for example, to simulate lettering, illustrative styles and even specialized printing techniques. Easy step-by-step guides demonstrate how to cut corners – and costs – to achieve high-

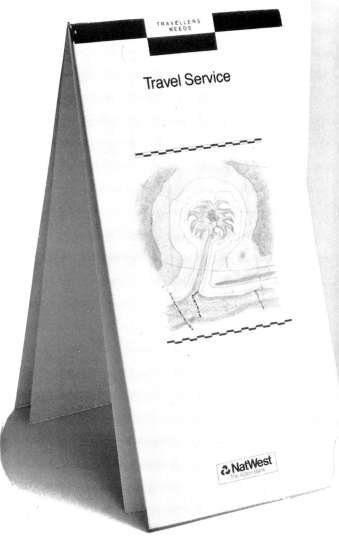

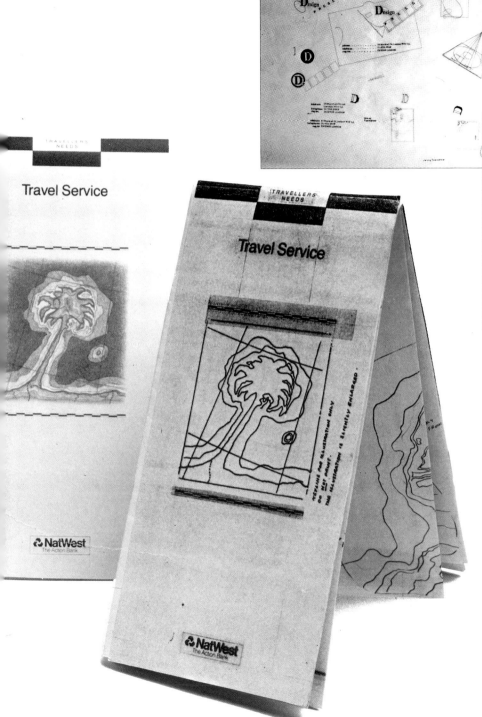

ly professional results with one-off presentations as well as more finished visuals.

The best preparation in the world, however, may well be worthless unless you have a proper brief and have precisely established the client's needs and market. This is not always as simple as it seems. Some clients cannot easily define what they want in design terms, although they know what they 'like'. In this instance, your first presentation should consist of a selection of rough visuals so that you can gauge the client's response to specific styles. Helping the client to clarify his or her ideas in such a positive way is the first step towards a satisfactory working relationship. Make notes at your initial meeting, listen carefully to what the client says, noting any preferences about, say, colours or typographic styles. Never be afraid to ask questions about points you do not understand or about things that have

All the examples on these pages show how varied the styles and ways of presenting roughs can be and why there is a need for studios and illustrators to specialize in specific areas.

■ **Right** This presentation gave the client a choice of ideas for a book jacket on watercolour. For speed the artist simulated the technique by using water-soluble crayons.

■ **Opposite, right and top** These two roughs were part of a series of presentation boards for a corporate identity for the Rockefeller Center, New York. The brief stipulated that the design would have to adapt easily to a whole range of items, from letterheads to uniforms. These particular examples, cut out from coloured papers, were incorporated into banners.

■ **Opposite, below right** This car-care kit was initially drawn using markers and stuck onto an existing tin. Although the original idea was used, note how the style has completely changed for the finished article.

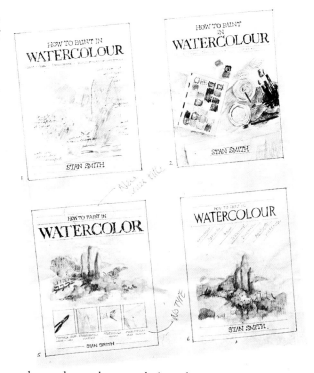

not been covered in the brief. Many designers find it useful to draw up a checklist not only of *what* is to be presented but, just as important, *how* it is to be presented. This can range from an informal one-to-one meeting to a group presentation using overhead projection or a slide show to take the client and his or her colleagues through the development of the design idea.

All this initial groundwork is, nevertheless, no guarantee that you will arrive at the appropriate design solution first off. You must expect your design to go through one or two modifications – and sometimes more – before it is finalized. That, after all, is what presentations are for and why the pointers in this book will prove invaluable in reaching an agreed solution with your client.

At the outset of a job, you will work on rudimentary roughs. Frequently, this involves the exploration of a number of different design ideas before one is selected above others – and then worked up into a preliminary rough to show to the client. If the client likes to be closely involved with the job, use these rudimentary roughs as an informal talking point, explaining how and why you arrived at your preferred choice. It is not worth your while to produce highly detailed visuals at this stage and it can also be counter-productive, because it might suggest to the client a rigidity of approach. Take note of all the client's comments and modify your design accordingly. If there are valid aesthetic reasons for rejecting some of his suggestions, say so, and be prepared to demonstrate your point of view if necessary with appropriate roughs.

Once preliminary roughs have been approved, you will be obliged, in most instances, to produce more finished visuals. Agree with the client precisely how finished these roughs should be

and to whom they are being shown. For many highly finished roughs you will need to employ the services of a specialist – for example, a professional lettering artist, illustrator or photographer. Make sure your budget covers these kinds of costs and be prepared to brief these specialists accurately, using the tips given within these pages, so that you get exactly what you want.

The formal presentation of finished roughs to, frequently, the client's directors and sales managers can seem a daunting experience but if you have worked closely with the client through all the presentation stages, are confident that your design is right for the job and have produced visuals to a high standard, then you have little to fear. Following the advice given in this book, you can not only produce outstanding presentation visuals but also manage the presentation itself with all the expertise in the world.

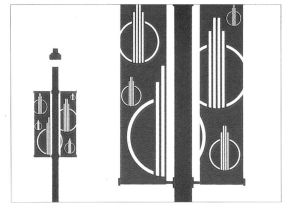
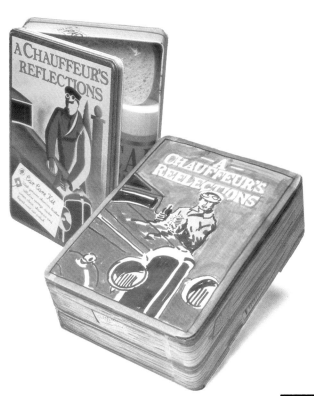

Initial concepts

EVERY DESIGN JOB starts with a brief from the client and this can range from the most informal chat to a written report supported by detailed research material. It doesn't matter how you get the brief so long as you make sure you know *everything* you need to do the job *before* you start.

Whatever the nature of the brief, you must understand and establish at this stage who the job is to appeal to and exactly what it is supposed to communicate. Markets are people: try and imagine who each job is for and what your design must do to excite them. Never be afraid to ask the client as many questions as are necessary to determine what the client's market is.

It goes without saying that money and time determine the type of design solution arrived at and affect the method of presentation. Inexperienced designers particularly should be aware of these constraints from the outset, bearing in mind that a low-budget job should never affect the quality of the presentation but merely its nature.

The scale of the job, its budget and the actual conditions of presentation determine the method of presentation as well as the type and number of roughs presented. Ask if the client needs to show the material to other people. Is the chairman of the company attending the presentation session? If so, you may need to make the presentation more for-

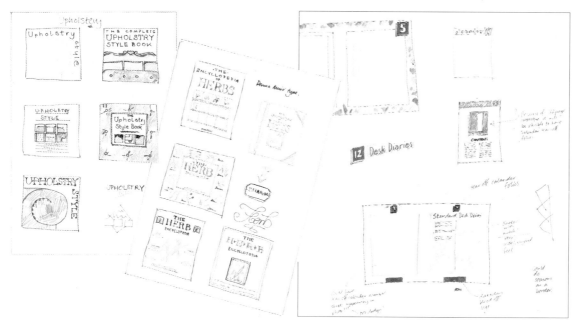

mal. Discuss the physical conditions under which the presentation will be made and agree with the client on the method of presentation as well as the number of roughs he – or his colleagues – might expect to see for that job. In this way presentations that are too sophisticated or simply inappropriate can be avoided.

ROUGHS AND THUMBNAIL SKETCHES

After the graphic artist has been briefed by the client, the in-house art director or design head, his initial task is to produce first roughs. Essentially, these are ideas for the design put down on paper in the form of quick sketches and drawings. Generally first roughs are drawn with pencils or felt-tipped pens, but almost anything can be used, depending on the artist's preference.

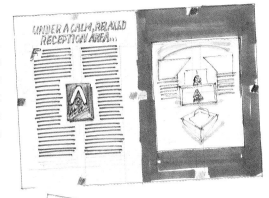

■ **Left** Marker rendering has been used on these brochure roughs. Note how the type is roughly indicated with drop caps and parallel lines while the headings quite carefully simulate the suggested typeface. Of the two designs, one is quite formal, the other more lively.

■ **Right** For these five alternative logo roughs, markers have been used to produce distinctly different designs. It is to the designer's credit that these look like first roughs rather than working drawings and his skill as a freehand lettering artist is obvious. The beginner can, of course, achieve the same standard by tracing the letters from a type book. Note that the centre design is a photocopy of hand-rendered type.

The aim of first roughs is to explore and evaluate ideas in a variety of ways within the limits of the brief. In most cases, preliminary roughs are meant to be talking points that will be amended, re-thought or discarded according to the client's comments. Only then is an acceptable creative idea decided upon.

Many designers do a series of miniature sketches or doodles known as thumbnails – and as the saying goes, some of the most brilliant designs have been scribbled on the back of an envelope. Do use thumbnail sketches if they communicate your ideas better than full-scale roughs, but make sure that your client or art director will accept this form of initial presentation. More often, thumbnail sketches are used to try out ideas and narrow the artist's range of acceptable designs before presentation first roughs are made. However, they can also be a useful means of 'note-taking' or of expanding ideas on the spot when discussing an idea with a client.

However loosely your preliminary rough is drawn, it must follow basic design principles and correspond to the client's brief. If the subject is to be treated typographically, the heading and other type should have the correct weight, emphasis and visual appeal and be laid out appropriately on an area or page of the right shape. If, for example, a visual image is to be used either alone or in conjunction with type, the artist must decide what type of image to use and, in the latter case, how type and image should be related. Even with a very rough design, it must be obvious at a glance what you are trying to communicate.

The standard of roughs depends on the person you are presenting the roughs to. An in-house art director is unlikely to want detailed roughs; a sales manager, on the other hand, who can perhaps evaluate only what he actually sees, might want more precise sketches. Clients also vary enormously in their visual appreciation. Many prefer freely-drawn roughs or even on-the-spot thumbnail sketches, because they then feel that they are actively involved in the design process. Others need relatively finished roughs, which can be time-consuming for the designer, in order to make a decision. It is advisable to establish at the first briefing how many roughs, and to what standard, the client deems necessary

■ **Left** Shown here are the types of doodles produced by a designer when thinking through the client's brief. This is really a form of visual note-taking and is often done at the briefing session or as soon as possible after, as a kind of memory aid.

to agree on a final design. In this way, the time and material costs involved in a number of roughs or finished roughs can be incorporated in your costings for the job.

It is of course important that the roughs, whatever type you produce, should be presented professionally and in a style that can be understood and appreciated by the client. His confidence in your creative abilities must be assured – after all, he is paying good money for your ideas.

■ Left The doodles opposite formed the starting point for these stamp designs on the theme of urban renewal. The designer first explored the simple idea of random but thematically-linked objects held together by a title. These were most effectively visualized in preliminary roughs using markers (left and below). The client, however, preferred a photographic image with graphics overlaid on acetate for the presentations (below left and bottom left). He finally opted for the scroll design, an initial idea sketched on the doodle.

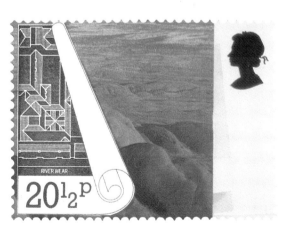

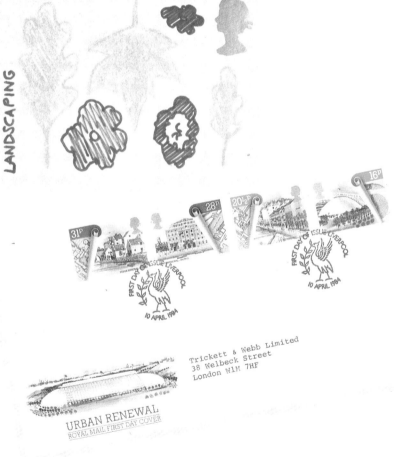

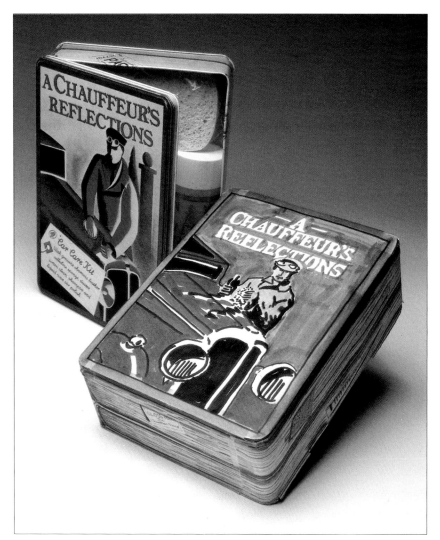

■ Above These roughs for a package design were simply wrapped around a biscuit tin and attached with low-tack adhesive for easy removal. The design consultancy wanted the gift packs to look like a series of books so all packs were designed to look like 'pages' and 'spines'. The presentation was made in marker pens on layout paper.

SIMPLE MOCK-UPS

A simple mock-up is a rough, three-dimensional model, for example of a packaging design, showing size, shape, colour and design of the finished product. Essentially it serves the same purpose as a flat rough, and is presented as a preliminary design concept.

A simple mock-up is necessary for an initial presentation only when the design deals with a three-dimensional product such as a pack or point-of-sale container. Usually, the mock-up follows the approval of a presentation rough in which the container's shape and size, and the colours and graphics for its surface have been suggested. A flat rough can often be misleading, especially for a client not used to dealing with visuals. Therefore a mock-up is produced, showing how the pack actually looks in three dimensions, giving an idea of its scale, bulk and eventual appearance.

It is important to remember that the simple mock-up is the same as a preliminary rough. It is not meant to be a detailed or finished model such as those produced by architects, engineers and industrial designers; in the graphic design presentation that comes at a later stage. As an initial presentation technique, a mock-up is only practical if it can be constructed readily from card or plastic or sculpted into the appropriate shape or size from an easily workable material such as polystyrene. As with first roughs, neither too much time, money nor effort should be put into simple mock-ups – unless these factors have been budgeted for.

The mock-up should, of course, be well-executed in that it is full size or proportionately scaled, but the rendering of the design should be fairly broad. The advantage of a mock-up over a rough is that it offers the chance to evaluate the

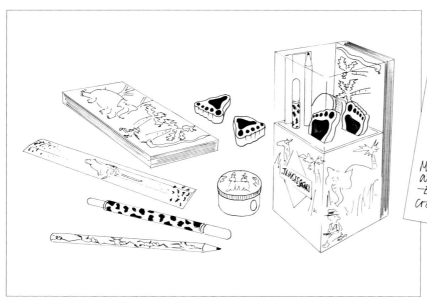

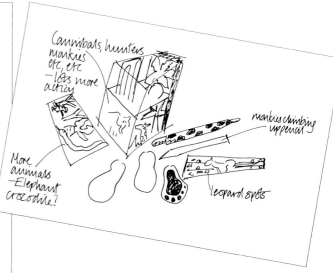

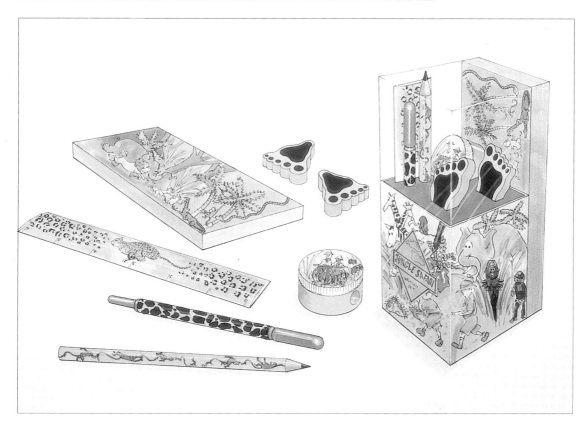

■ **Above and Left** In consultation with the client, the designer chose a safari theme for the initial concept for a writing set. The first rough, rendered in pen and ink, was worked up into a more finished rough that incorporated the client's written suggestions, before the presentation itself was completed using marker colours that reflected the original idea.

■ **Above** Flat plans are mapped out for TV story-boards, as well as books and brochures. A fine-tipped black marker was used for the preliminary rough of a TV advertisement for sweets. Coloured markers were used to visualize an alternative rough for the same storyboard.

approved design more accurately in terms of volume and scale and the relationship of the graphics to these qualities. Amendments and alterations are not infrequent at this stage, because the transition from two- to three-dimensional images can subtly alter the perceived effectiveness of the design.

FLAT PLANS

A flat plan is produced whenever the design project involves a booklet, brochure or book. At the initial stages of the design, the flat plan is an essential guide to whether the idea works, given practical considerations such as page size or format, the number of pages, the extent of colour and the desired number of pictures, plus the ratio of pictures to text. As most of these things will have been discussed at the brief, the initial flat plan explores the possibilities of an idea within the limits imposed. Basically, the flat plan shows what will appear on each page of the publication. This is done very roughly, page by page, on a small-scale plan of the entire book or booklet, with picture areas indicated by boxes and text by lines. Covers, preliminary pages and end matter such as glossaries and index must all be taken into account.

The subject matter of the brochure or book obviously dictates the way the flat plan is structured, so before the designer starts out, he should have as detailed a synopsis as possible of the book's contents. It is also important to know the

■ **Right** A sample spread showing the relationship between pictures and type is often presented along with a flat plan.

Dangerous house plants

Plants to avoid

■ **Left** This detailed flat plan for a historical atlas shows how effective this type of 'selling tool' can be. The line work has been done with a drafting pen and the visuals coloured in crayon.

approximate number of words in each section or chapter and whether these sections will be illustrated heavily or lightly. Although at this stage no actual text or pictures are in the designer's hands, the rough flat plan should show the overall balance of the material.

The detailed flat plan is produced once the text has been written and the style of illustration has been determined. The designer can now depict more accurately the relationship between words and pictures and finalize the grid. Detailed flat plans are often produced for brochures and booklets when the approval of, for example, salespeople is necessary; they are provided less frequently for books, unless the client or publisher has stipulated a fairly rigid formula.

Although they are a part of every designer's repertoire, diagrams are used mainly by architects and technical designers to show how information will be conveyed in a proposed design. The choice of diagrammatic approach depends on the nature of the project and on how much information or instruction needs to be incorporated. Among the possible range of diagrams to use are cross-sections, cut-aways, flow charts, exploded drawings, pictograms and narrative diagrams.

■ **Left** The two examples here show different styles of presentation flat plans for a brochure. One (far left) juxtaposes text and pictorial matter on opposite pages. The other integrates them. It was left to the client to choose which he preferred.

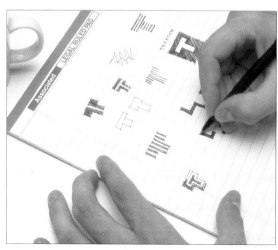

■ **Left** Central to both the above designs was the T logo. The designer's initial ideas about how to develop this into an effective graphic image were worked through roughly. His suggested solution is included in the flat plans.

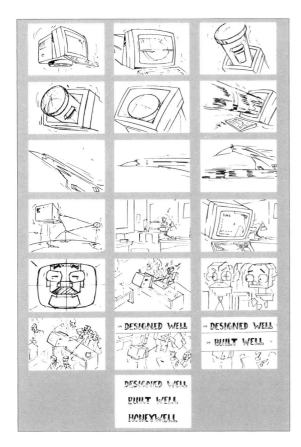

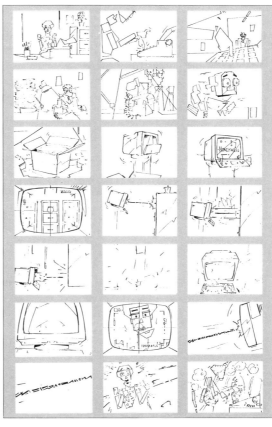

■ **Above** This alternative design for the computer TV commercial utilizes the same 'cubist' figures to add humour and humanity. At this initial stage, the storyboard is executed simply, although with some detail, in black and white. Once the content and style of the commercial are agreed, further more detailed roughs will be produced in colour.

Many of these techniques can turn out to be laborious and time-consuming and, consequently, for an initial presentation it would be absurd if the artist did more than just a rough representation of the idea in question. Some clients have difficulty in reading diagrams, so the visualization, however rough it may be, must show clearly how the information will be conveyed. If even a rough diagram needs explaining the message has not been received. Only after the diagram has been accepted should you go on to produce a more detailed version. Since all diagrammatic representations call for utmost accuracy, it may be advisable to hand the detailed presentation job to a technical illustrator.

Type and lettering

MOST DESIGN JOBS require type or lettering of some kind and all graphic artists need to have some knowledge of typography. It is important to take care in presenting typographic ideas in rough form, for typography depends for its success on detail, feel and precision.

Too often the designer takes the easy option and chooses a typeface such as Univers, which is widely used and generally acceptable – but without exploring alternative faces which might be more appropriate for the job in hand. Do choose a typeface with care; for example, does its character fit the job; will it read well if reversed? Explain to yourself beforehand – and then the client, if necessary – the reasons for your choice of type. Study instant lettering and typesetters' catalogues before you make a final choice to make sure your preferred typeface really is conveying the image you want it to.

Typesetting, of course, nearly always gives the best results but, usually, this is only appropriate for highly finished presentations. Instant lettering or hand lettering are normally used for most presentation visuals. The most important considerations are readability, spacing and fitness of purpose. If you are inexperienced, rough out type first before working directly onto presentation visuals.

Although hand rendering of type can seem daunting for the beginner, there are templates and other aids which now make this relatively easy. Carefully mark out the base line, x-height and cap height, and use tracing paper to copy the letters from a typesheet. Do this initially in pencil, adjusting the spacing as necessary before finishing in black or coloured inks on the presentation roughs.

HAND LETTERING

Hand lettering – or the construction of letter forms – is an art that according to some is almost obsolete. But this is a limited view considering the continued demand for imaginative logotypes and mastheads, especially as many of these cannot be produced by mechanical means because they are outside the range of type styles available. Strictly speaking, hand lettering is a specialized skill which the designer normally puts out to an experienced lettering artist after preparing a rough of the type or style of lettering required. Specially commissioned hand lettering is always expensive but it can be essential for the final presentation of many designs.

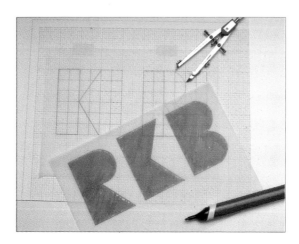

■ **Right** To construct simple letters, draw a rectangle or square on sectional paper or a tracing paper overlay. Construct the letter using compass, ruler and templates, repeating the main features for each letter so that the letters B, P and so on are made up from the same basic design construction.

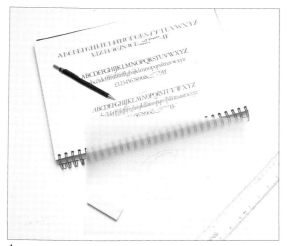

1

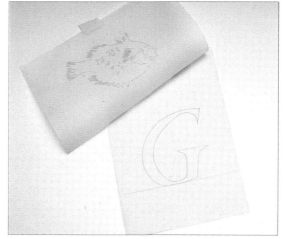

2

3

4

5

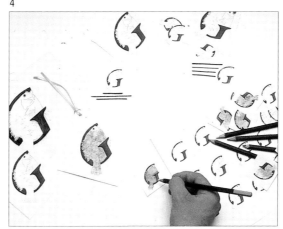

6

Designing a logo

Letters can be modified to be incorporated with an image in a particular logo design.

1 Choose a suitable typeface and enlarge the letter to an easily workable size.

2 Enlarge the image to be incorporated to a corresponding size, match up the two pieces of tracing paper and attach to each other with masking tape.

3 Attach a clean piece of tracing paper over the work and trace both the letter and the image onto the same surface. Remove the masking tape and attach the last sheet of tracing paper to a piece of sectional paper.

4 Using templates, ruler and a drafting pen, carefully work over the design, correcting lines and curves, always drawing curves first, then matching straight lines up to curves.

5 Fill in the design or letter with ink, using a drafting pen or for larger areas a watercolour brush and drawing ink.

6 Use the drawing as a master design which can be photocopied, enlarged or reduced to experiment with repeat patterns, composition, colours and textures.

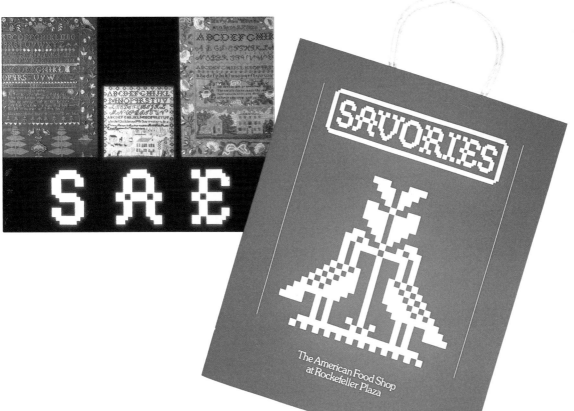

Left The type and visuals on this striking design for a carrier bag are derived from sampler lettering. The presentation boards actually included photographs of historic samplers to show to the client the precise source of the letters' design.

Above These simple but distinctive designs show how the letter T can be constructed in different ways.

Left This book jacket's title relies on constructed letters to achieve maximum impact. The first two roughs were rendered in crayons with the more finished one made using rubdowns. The printed jacket is based on the centre rough, with only minor alterations.

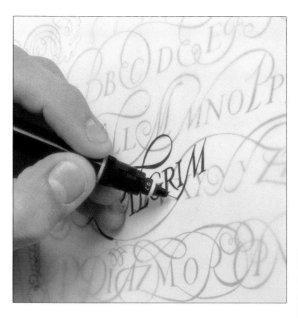

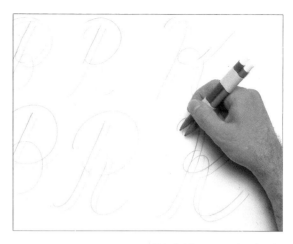

CALLIGRAPHY AND CURSIVE LETTERING

Calligraphy literally means 'beautiful writing'. Orthodox calligraphy is an acquired skill, and a range of different pens and nibs is available to help create special effects. Like hand lettering, calligraphy is usually commissioned from a lettering specialist.

Cursive lettering, on the other hand, can be an uncontrived yet refined version of a personal handwriting style. In fact, all graphic artists would be advised to develop an aesthetically pleasing hand – it is, after all, an expression of the way you think about design in general.

Cursive lettering can be used to give fluidity and spontaneity to a design when more formal lettering would be inappropriate. Architects and draughtsmen frequently insert fine hand-written lettering on technical drawings using a technical pen, but graphic designers can make use of markers, felt-tip pens, coloured pencils or crayons to create free-style lettering for slogans or titles on presentation roughs.

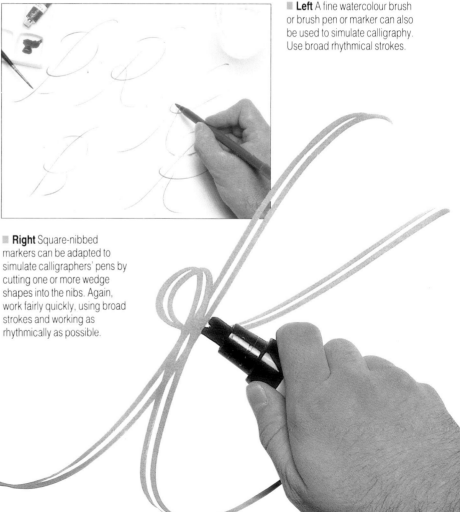

■ **Left** Calligraphy combined with conventional type can make an impressive design. This first rough was worked in pen and ink although the design was later modified into a landscape frame.

■ **Right** The final presentation rough used a flat mauve background with the conventional type rendered in gold and the calligraphic letters in a gloss red. The design was processed by omnicrom which succeeded in giving the presentation a depth and richness reminiscent of hand-illuminated manuscripts.

■ **Left** The sub-heading on this design is rendered in a relatively simple calligraphic style. For this presentation rough, the letters were outlined in pencil and filled in with watercolours.

F·L·O·W·E·R
W·O·R·K·S

Innovative ideas for bringing
the beauty of fresh and
artificial flowers
into your life

PRINTING
IS ON THE SIDE
OF THE PEOPLE
WHO
STILL HAVE
THE COURAGE
IT IS AN

I have not to think about them

We have the privilege of turning back from the page ... at the end
we have found something debatable, in order to return to
that point where the argument started ... Whether we read
to the end, or far enough ahead to see what
is drift ... onwards ... And the third privilege is to leave ... about
... at any word or sentence ...
... meditation, verification, ... summary.

Beatrice Warde.

Design Typography, Calligraphy, Clive Bruton-Fowden 1991/p-1991 • in collaboration with Department of Graphic Communications • Loughborough College of Art and ...

▪ Hand rendering text and headings

1 Choose a suitable typeface and size. If there are headings of different importance, choose a typeface which is available in many different weights.
2 Trace the longest heading in a single line and decide from that whether it should be designed to fit into more than one line.
3 Draw up the grid onto which the text and headings have to be applied.

1

2

3

HAND RENDERING OF TEXT

There are various ways text can be rendered, depending on whether you are working on a rough or finished presentation and whether you want to show real or dummy text. Solid lines and broken wavy lines are the simplest ways to indicate text. However, tramlines – that is, sets of parallel lines – give a more accurate indication of the type because the lines are drawn to the x-height of the type face and size chosen. Indents and drop capitals can also be shown on tramlines, which are usually drawn in grey with a fine-tipped pen.

Tramlines look neat and precise on a more finished presentation, especially if you for various reasons do not want to show dummy text or real lettering. Solid and broken wavy lines are obviously more suitable for rough presentations but can be used to good effect at later stages to indicate an informal approach.

GREEKING

Greeking is the construction of letter-shaped forms that look rather like Greek script, and is most often used when the designer literally does not know what the text is. Dummy text and even Latin body text can sometimes convey inappropriate information; Greeking, however, simulates text without recourse to actual words. Usually, it works best in small type sizes and is visually attractive when performed confidently.

Greeking may also be useful when a proprietary name needs to be deliberately obscured.

TRACING

There are a number of other ways to hand render text for headings, letterheads and display in order to reflect accurately the type face and size cho

4

5

6

8

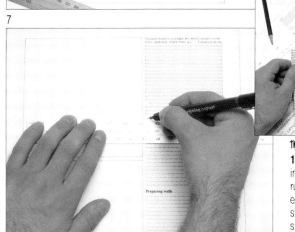

9

4 Make a rough paste-up of the heading and trace this through to a clean piece of tracing paper.

5 If this is too rough to use on the layout, retrace the letters from a type specimen book, using the rough paste-up as a guide.

6 Having chosen a suitable typeface and size for the running text, trace one or two lines of the first paragraph or block of text to give an indication of the type style.

7 The rest of the text is indicated by tramlines drawn to the x height of the type chosen. Note that in this example, the text is justified with the beginning of each paragraph indented.

8 For precision with hand lettering, particularly when the text is justified, calculate the number of characters that will fit on a line.

9 Continue to indicate the rest of the text by drawing in the baseline and x height of each line, closing up the ends of the line. To suggest type that is ranged left, simply vary the lengths of the line.

10

10 A very quick method of indicating large areas of running text is to photocopy existing type in the appropriate style and size from, say, a type specimen book and use this for a rough presentation.

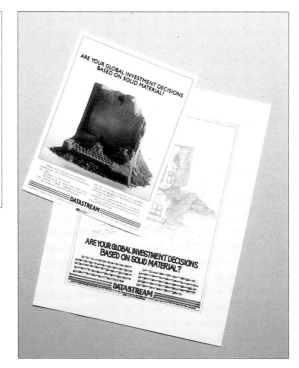

Cuti fugitant uitanti sol per
manast ipsisus,et alte arert.
 Quista us compestius et
quod semina oculis multa et
cuti sol etian.
 Praeterea et sol contra is
fluunt sol is est simulacris
multi solis pergas etiam sol
quod composituras et quod
mutas splendor sol quarto.

■ **Above** Among the various
ways of indicating type are
tramlines, wavy lines and Latin
text copied freehand in the size
and style of the chosen type.

■ **Right** On the marker rough
for this advertisement, the
headings are simulated in the
typeface and size of the
finished article but the text is
indicated by wavy lines.

■ **Above** In this fairly finished
presentation, real text is
combined with tramlines, wavy
lines and hand-rendered
lettering, including coloured-in
drop caps. A light-coloured
marker was used to lay a wash
over the illustrations, making
them look more authentic and
separating them more clearly
from the text areas. Although
the final layout was changed to
incorporate more illustrations,
the typographic layout
remained unchanged.

Tracing is the most common way of doing this:
by means of detail or tracing paper, each letter is
copied from a typesheet. One method is to use a
pencil when working out the design to attain
correct spacing and legibility, and then to retrace
with a rapidograph or coloured ink for a more
finished result. Some designers can do this
freehand, but only if they are particularly fam-
iliar with the typeface.

Enlarging or reducing traced type can be done
with a photocopier. This is invaluable when de-
signing letter heads, logotypes and so on. If the
trace is worked fairly large it can be enlarged or
reduced to various sizes with more or less abso-
lute accuracy – in virtually no time and with little
expense. The same thing can, of course, be
achieved with a PMT, although this method is
more costly and time-consuming.

DRY TRANSFER LETTERING

This is one of the most widespread presentation
aids, used by beginners and design studios all
over the world whenever lettering is required. It
presents the designer with an alternative to hand
lettering that has the quality of typesetting, is
relatively cost effective (although not cheap) and
offers an extremely wide range of type faces and
sizes in a number of different colours. Instant
lettering also provides dummy body text, which
is particularly useful for book or magazine design
presentation.

The major manufacturers of dry transfer
lettering, such as Letraset and Mecanorma, pro-
duce the most popular and comprehensive range
of instant letters. Over 500 type faces in some 25
point sizes are available, as well as a number of
type styles in Greek, Cyrillic (Russian), Arabic
and Hebrew alphabets, along with Roman and
non-Roman numerals. Particularly useful for

presentation purposes is the dry transfer stencil, which allows the inside of the letter to be painted. The outline of the letter is then lifted, leaving the perfectly painted letter. Body type used to produce instant 'text setting', architectural and technical symbols, musical notation, corners, decorative borders, rules and dotted lines are additional, readily available design aids.

Instant lettering is an ink image printed on a transparent plastic film and coated with a special adhesive. Each letter is positioned on the artwork, then pressure is applied to the upper surface of the sheet by means of a spatula, pencil or burnisher until the letter is transferred. Corrections can be made by simply peeling off the letter with a strip of clear adhesive tape or masking tape. To ensure a well spaced, even effect, some proprietary instant lettering incorporates a spacing system with registration marks, although the trained eye can often achieve a better result. At first, instant lettering may not be particularly instant, because each letter has to be applied separately and it requires a certain amount of practice and skill to make it look professional, especially when it is applied to awkwardly shaped objects or difficult surfaces.

It would be only a slight exaggeration to say that instant lettering has revolutionized presentation design and is probably the single most valuable tool in the designer's repertoire. It is relevant in almost every aspect of design, but particularly in the world of advertising where the demand for novelty has led to a continuous extension of the range with new faces designed by reputed typographers. Like off-the-peg clothes, instant lettering reflects whatever is fashionable and trendy, be it the now passé 'art deco' or such current favourites as 'faces from the 50s'. This is, of course, a boon to the designer whose client asks

■ Applying dry transfer instant lettering

1 Rough out the basic design and wording on tracing paper.
2 Attach the rough design to the presentation surface using masking tape. Slip the dry transfer sheet in between, covering as much of the transfer sheet with its backing paper as possible, for protection. Gently rub down the appropriate letter using a soft pencil, the back of a scalpel handle or a proprietary tool.
3 Gently lift the dry transfer sheet away to reveal the letter on the surface.

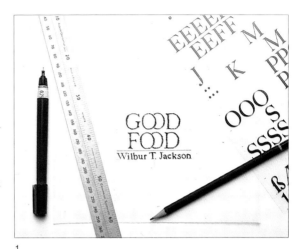

1

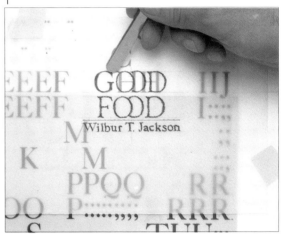

2

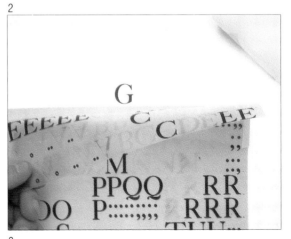

3

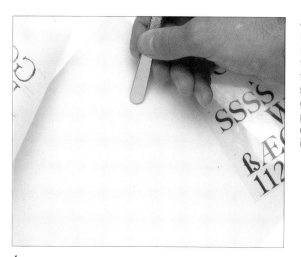

4

5

4 Put the backing sheet over the letter, obscuring it, and gently rub over it to make sure that all the corners and edges are firmly stuck down.

5 Using the rough trace as a guide, place the next letter in position, making sure that it sits on the baseline and rub it down in the same way.

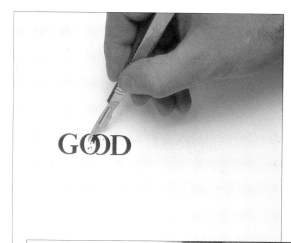

6

7

for something up-to-the-minute, but the less avant garde are also well (if not better) catered for. The bestsellers in the instant letter manufacturers' catalogues are old favourites like Univers, Futura, Baskerville and Bodoni, the staples of good, workmanlike typography, in everyday use by graphic designers.

With so much to choose from in the instant lettering range, the designer's main task is to narrow the choice of typographic styles to those that suit the brief, the client and the product – to use lettering in a way that enhances or reinforces an

6 To remove parts of letters, make a neat cut through the letter but be careful not to cut into the surface of the paper, then remove the unwanted part of the letter with a scalpel blade.

7 To correct mistakes or take off broken letters, use a piece of masking tape and rub it gently over the letter to be corrected, then lift the tape. It is a good idea to test first if the masking tape will take off the surface of the paper. If the letters to be corrected are very small or if they are close to other letters, use paper to mask off the areas.

Right White lettering is transferred in the same way as black lettering. If the lettering does not appear opaque enough, use a second layer of white lettering over the first.

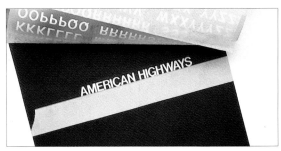

Right Pre-releasing may be necessary when working on very soft or awkwardly-shaped surfaces. Lift the dry transfer sheet away from its backing sheet and gently rub the letter with an appropriate tool. The letter will look grey rather than black when it has been released from the carrier sheet. Transfer the letter to the work surface, pressing lightly with the fingers. Proceed to rubdown in the normal way.

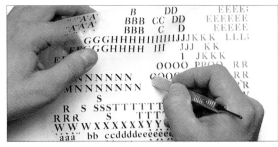

overall design concept for a *particular* product.

RUBDOWNS

Rubdowns are custom-made dry transfer designs. They are used frequently for detailed presentation roughs when the design combines lettering in different type faces and sizes and/or incorporates decorative or textured features that are outside the range of instant lettering catalogues. Like other dry transfer systems, the lettering design can be produced in a number of colours and in specified sizes. The dry transfer sheets, which are made from the designer's own artwork, are used as rubdowns in exactly the same way as proprietary brands. Like proprietary dry transfer sheets, rubdowns are not cheap, but they constitute the only way to apply type and images directly onto surfaces without the use of cells or without printing.

1

2

3

How to colour instant lettering

To colour instant lettering, you need an instant lettering positioning system.

1 Rubdown white instant lettering onto a paper transfer strip.

2 & 3 Spray the lettering with an air marker containing your chosen colour. Spray evenly for a single overall colour, or as appropriate for graduated or mixed colours.

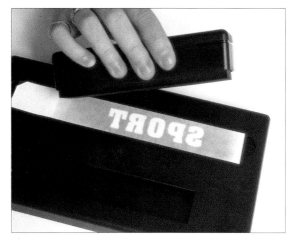

4

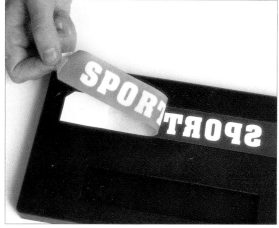

5

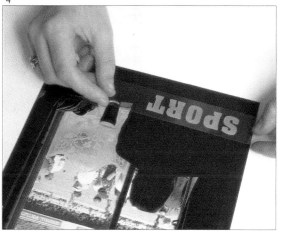

6

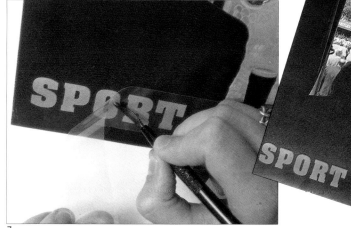

7

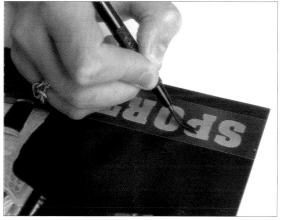

8

4 When the colour is dry, place the paper strip face down onto the transparent transfer sheet. Thoroughly dampen with the moistening pad.
5 Peel away the paper sheet when the letters have been transferred onto the plastic strip.

6 Position the plastic strip, now with coloured lettering, onto the layout.
7 & 8 Rub down in the normal way before carefully removing the transparent strip. Burnish again to bond firmly.

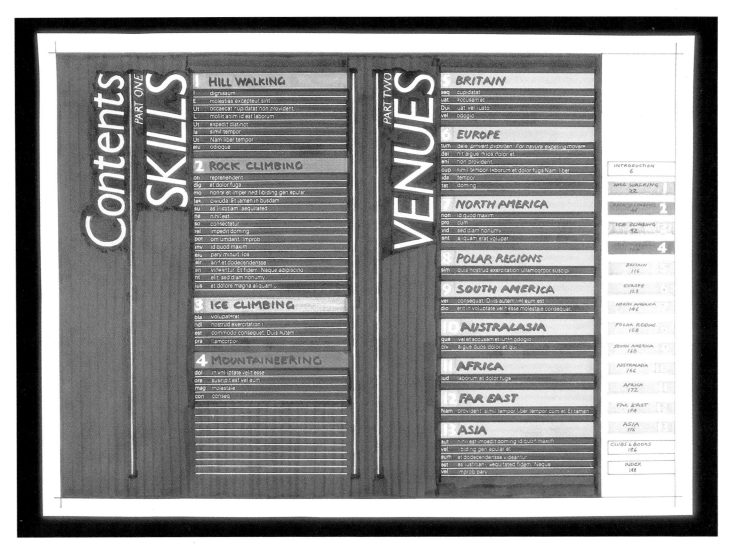

Contents

■ **Above** White Letraset body copy has been used to represent text on this dummy spread for the contents of a book. The background was laid in using markers, whereas the headings were hand-rendered – making for a successful combination of media on one presentation.

■ **Positioning type using instant lettering**
Dry transfer instant lettering manufacturers now provide an easy-to-use system for positioning type which allows the designer to see at a glance how the words or blocks of type look in different positions. The basic kit provides a moistening pad and 25 two-part transfer sheets.

1 & 2 Rub down the words or phrases (in this case, the heading *Staying Healthy*) from an instant lettering sheet onto a special paper transfer sheet (provided in the kit). These transfer sheets are small 30 × 210mm strips and can take type sizes up to about 20mm cap height. Larger sized transfer sheets are available for larger type sizes or blocks of type.

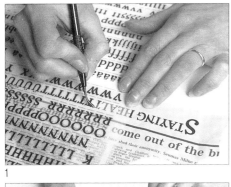

1

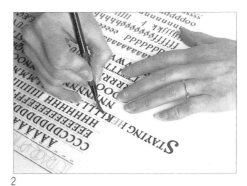

2

3 Put the paper transfer sheet, type side down, onto the transparent transfer sheet. The black base unit which holds the strips for easier working can be purchased with the kit.

4 & 5 Using the special moistening pad, thoroughly dampen the paper sheet.

6 When you peel away the paper sheet, you will find that the lettering has been transferred to the transparent film.

7 Position the heading on the artwork.

8 Rub down in the normal way before carefully removing the transparent film. Burnish again to create a firm bond.

9 The finished artwork shows the type positioned as requested.

3

4

5

6

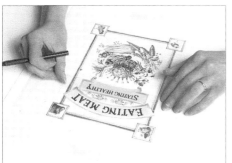

7

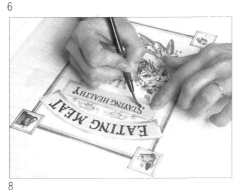

8

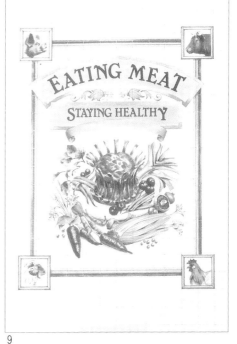

9

1

2

3

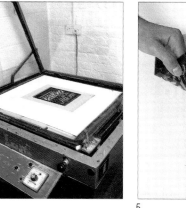

4

5

6

7

8

9

10

■ Rubdowns

The image from which the rubdown will be made has to be converted into a negative.

1 The transfer sheet is placed onto the board and ink is spread along the top and 'pulled' down over the sheet with a metal rod. This is the most tricky part because the surface must be perfectly even.

2 When dry, a layer of white ink is laid down in the same way to give extra strength and depth to the chosen colour.

3 Two subsequent layers are then added: an ink powder – for an extra-smooth finish – and a coating that is sensitive to ultraviolet light.

4 The whole sheet is then placed onto the screen with the negative on top.

5 Once this has been exposed the negative is removed.

6 & 7 The sheet is then placed back on the board and developer is pulled across to remove the excess light-sensitive coating from the unexposed areas. An ink developer is then applied in the same way to remove the excess ink.

8 Before each layer is applied the previous one must be completely dry, a process that can be speeded up using a domestic hairdryer.

9 A non-residue adhesive is then spread over the sheet to attach the image to the surface when it is rubbed down.

10 A protective backing sheet is stapled to the rubdown before it is finally trimmed and ready for use.

■ **Right** This art deco design has been produced from a custom-made rubdown. This is a quite intricate visual using white and gold on a green background. When rubbing down an entire sheet like this, work carefully from top to bottom, smoothing and burnishing evenly.

■ **Left** In the processing of this specially produced rubdown, the black shadow and fine line work was laid down first. This illustration is a good example of the reasonably fine detail that can be achieved on such rubdowns.

■ **Above** Rubdowns provide a quick and relatively easy way of applying a background design to a pack presentation. Apply the rubdown, and indeed additional visuals, to the planes before you fold the box into its three-dimensional shape.

TYPESETTING

There are basically two types of typesetting – hot metal composition and photosetting. The rather inflexible hot metal process has been more or less superseded by photosetting, which is used widely by designers in all fields for finished presentations and for final artwork. The main advantages of photosetting are its flexibility and the extent to which it can be controlled. Character spacing, for example, can be varied to a fraction of a millimetre and lettering can be slanted backwards or forwards, interlocked, curved or distorted. Type can be produced in any size, and the range of type faces available from any one typesetter can run into hundreds. Because the range of faces and possible effects is so vast, many typesetters publish catalogues and it is wise to consult these to see what is on offer. With the introduction of computer and other electronic equipment, photosetting (including editing and correcting stages) has become extremely fast. Although typesetting is expensive, its great advantage in the design of finished presentations is that the same type can be used for reproduction – an important factor to consider that frequently warrants its expense.

■ **Left** Typesetting gives the finest quality when enlarged and offers the greatest flexibility in terms of line feeds and letter spacing. A great number of type distortions are also possible in a vast range of typefaces.

ABCDEFGHIJKLMNOPQRSTUVWXYZ

STENCILS, PAINTED TYPE AND CUTOUTS

Stencil letters are a handy design aid, particularly for the beginner who lacks confidence in free-hand lettering. Clear plastic stencils are the best because you can see the lettering progress and gauge spacing accurately. Work in pencil first and ink in only when the result is satisfactory. Metal templates should be used with a stencil brush loaded with ink or paint. For a crisper outline, use a fine line marker or technical pen and then colour in. Templates are also available for many of the symbols used by architects and product designers and are a cheaper alternative to dry transfers.

Painted type is frequently used in presentation design, particularly when the design involves a specialized logo. The image is painted in gouache or inks on the back of an acetate surface in reverse and then laid over the design. Letters can also be cut out of materials such as gold, silver and coloured papers, or textured papers and materials. This is a relatively cheap and easy way of creating unusual or dramatic lettering.

■ **Left** Stencil lettering is fairly crude when enlarged unless retouched by hand. It can work well, however, for preliminary or first roughs when cost is an important factor. For a more finished presentation, it needs to be carefully done.

ABCDEFGHIJKLMNOPQRSTUVWXYZ

TYPEWRITER TEXT

Typewriter text is frequently used in the design of office products and materials (pamphlets and circulars, for example), and modern electric machines offer a range of interchangeable characters in bold and italic type. Like tracings, typewriter text can be enlarged or reduced to suit design needs. Typewriter text can be used for body type as well as headings and is often employed in the production of low-cost newsletters and manuals. Even when cost is not a factor, typewriter text can be used imaginatively if the designer feels it is exactly right for the job – particularly if he wants to convey a sense of immediacy – although in general its uses are limited.

```
Culi fugitant uitantque tueni;
contra si tendere pergas propte
et alte aera per purum grauiter
feriunt oculos turbantia composi
splendor quicumque est acer ad
ideo quod semina possidet ignis
```

```
Culi fugitant uitantque tueri;
contra si tendere pergas propter
ipsius, et alte aera per purum g
feruntur, et feriunt oculos turba
Praeterea splendor quicumque est
oculos, ideo quod semina possidet
```

```
Culi    fugitant    uita
tueri;    sol   etiam    c
contra    si    tendere
propterea    quia    uis
ipsius,    et    alte    ae
purum   grauiter    sim
feruntur,    et    feriu
```

STRIKE-ON SYSTEMS

Strike-on systems are specifically designed to set type for reproduction, and they are relatively cheap. Basically, strike-on systems are sophisticated electric typewriters with interchangeable heads that produce letters in different type faces. Text can be set both justified and unjustified, but the range of type faces is not particularly wide and results vary. The output is never as good as conventional typesetting, although for presentation work strike-on systems can produce a highly finished result.

■ Typewriter text loses considerable quality when enlarged in a photocopier, but most machines can produce variable letter and word spacing.

ABCDEFGHIJKLMNOPQRSTUVWXYZ

LASER PRINTING

This revolutionary new development is a serious challenge to conventional typesetting. The laser printer can produce very high quality print that is indistinguishable from typeset material unless examined very closely – and its overwhelming advantage is its cost, which sometimes runs to almost half the cost of typesetting. A wide range of typefaces in sizes up to 120 point is available on disc and there is virtually no facility offered by typesetting that the laser printer cannot provide. For the designer it opens up a whole range of exciting possibilities. It can distort letters to create a range of effects – for example, sloping left or right to a specified degree – and can, among other things, print sideways. Not all design studios are able to afford the technology but for those who can or who have access to compatible software, there is the tremendous advantage of designing page layouts on screen which can be 'outputed' by the laser printer. Some of the more advanced equipment can even print on special overhead projection film and in different colours. An increasing number of freelance operators are offering their services to the trade and the cost saving, let alone the versatility of this type of printing, is a bonus no presentation designer can afford to ignore.

■ **Right** The quality of enlarged laser print is not quite as good as typeset material but, for the presentation designer, it is a much cheaper option. A wide range of typefaces are available and, as can be seen here, letter and word spacing is variable. Distorted letters can also be produced by laser printing.

Left For this finished presentation rough, typeset text has been copied by PMT and laid down with the colour prints of the artwork and photographs. Real text and headings are necessary for a final presentation like this when the client wishes to see the precise relationship between text and pictorial matter.

Right The text on this rough has been produced by an IBM strike-on system. Although it is obviously not as fine quality as typesetting, it more than adequately simulates its effects for presentation purposes.

Right The text is the most important element in this brochure presentation. It has therefore been typeset, then photocopied. After the photocopied text was laid down visuals were added, including the picture and the emphatic red marker lines. Background tone was then roughly introduced with markers.

Drawing and illustration

IN THE DESIGN WORLD, it is not necessary for you to be a proficient draughtsman to be able to render finished roughs. However, it is essential to have a good understanding of drawing media, styles and techniques and to develop visualizing skills that communicate ideas quickly and clearly.

One way of keeping abreast with current styles, artists and trends is to keep a visual reference file. Tear sheets from magazines, newspapers and mail order catalogues can all be put to good use, not only when briefing artists but also, if appropriate, in the presentation itself. For example, many designers who are uncertain about their own freehand style often copy figures or objects on presentation roughs to indicate the style or composition of the illustration they intend to commission.

On presentation roughs, keep the drawing as simple as possible. It is, after all, a simulation of content and style, not the real thing. Do, wherever realistically possible, work in the same medium as the commissioned illustration.

The best way to find an illustrator is through an

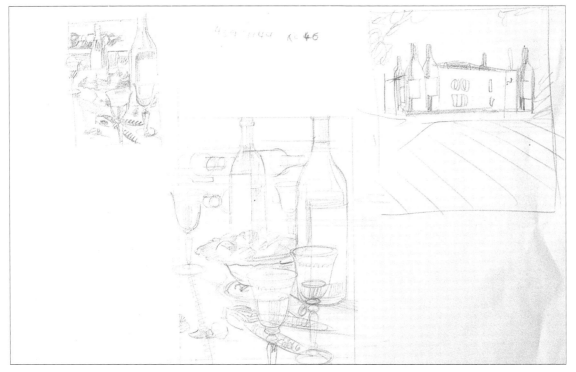

Left These preliminary pencil roughs show the artist's visual exploration of the wine bottles and glasses theme. The vertical composition in the foreground was the one chosen to be worked up for the client presentation.

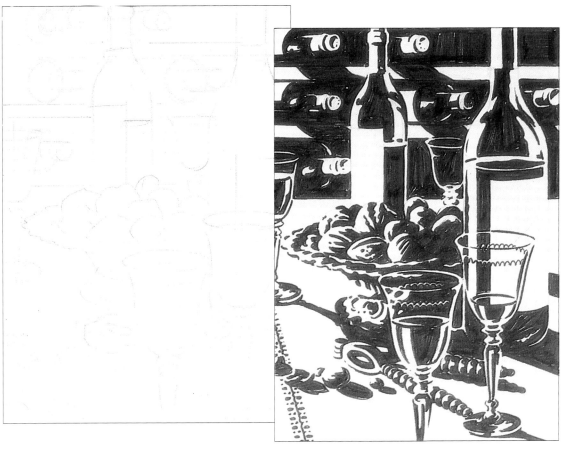

■ **Left** The pencil rough is taken a stage further (far left). Although the composition remains the same as the preliminary rough opposite, the illustration is rendered with greater technical accuracy. Note the vertical and horizontal lines which have helped the artist achieve this. Following the approval of the pencil rough, the drawing was worked up with a black marker (left) to simulate a woodcut effect, as discussed at the briefing session.

agency or illustration annual where you can study samples of different work. Having found a suitable illustrator, be precise about what you want. If you have done presentation roughs yourself, use these as the basis of the brief. Establish the media to be used, the colours, size (usually one-and-a-half or twice up), surface, the budget, and time available. Make sure the illustrator submits fairly detailed roughs for approval before proceeding with the final work.

ILLUSTRATIVE DRAWING

When preparing rough visuals of an illustrated page or pages, the graphic artist draws in pictorial matter together with an indication of the text. Fibre or felt-tip markers are the most popular but not the only medium for doing such drawings. For more finished visuals, it is sometimes appropriate to integrate photographs or the illustrator's first roughs (drawn either on the same sheet or on another one and then fixed on top of the layout-sheet with the type rendering, etc). When the rough has been approved, the illustrator proceeds with the finished drawing. Generally, the graphic artist uses illustrative drawing in two ways. One is to rough out ideas for a design or to suggest the composition of a pictorial image that is incorporated in the design. The other is to simulate an illustrative style or photographic treatment before actually commissioning the work.

■ Right This relatively finished pencil drawing has been juxtaposed with text on this book presentation spread. The illustration shows how effective a medium the pencil can be in its own right – in this instance, creating the desired 'period' feel through a combination of fine line and shading.

CIDER WITH ROSIE

e glen the track from the village
nded at a pair of wide gates. These
s of access to the castle, which
h granite walls. To the rear Bond
well be the ruins of the original
ore like a great Gothic-style heap,
and turrets.

main door—a wide structure with
s set in the midst of large formal
t produced a half-sinister, half-
ard, Bond could just make out the
er of a marquee. For tomorrow's

to the car, drive back and present
hen he realized, too late, that he

the craft of professional hunters,
ke spirits of the night. But these
eir leader who now loomed huge
le, eh?" the giant accused him in a

I began, raising a hand to remove
ed, so two hands, the size of large
and lifted him bodily into the air.
?" the giant said.

quietly with anybody. He brought
big man on the forward part of his
d let go of Bond. A trickle of blood
ils. "I'll kill ye for—"
m behind them. "Caber? Hamish?

slight nasal twang of Mary-Jane
l. "You remember, Miss Mashkin.

ou doing here?" She peered at the
you, Caber?"
e neb," he muttered surlily.

145

QUICK WAYS TO VISUALIZE

At the beginning of the design, the traditional wood-encased graphite pencil is often the first tool the designer uses to quickly put down ideas previously only mentally visualized. Pencils come in various grades from very soft (such as 4B) to very hard (4H); HB is probably the most suitable for the rapid freehand sketches the designer draws on layout paper. The softer and harder leads are used, alone or in combination, by the professional illustrator or draftsman to create different effects. The paper surface, too, determines which grades of pencil should be used, with softer pencils more suitable for rough or grainy paper and harder pencils for smoother surfaces. Should the designer want to, he or she can use the pencil to create shading effects and to simulate various textures using dots, lines or freehand hatching. On the whole, however, the graphic artist uses the pencil for rudimentary roughs or for artist's reference sketches. These usually (but not always) form the basis for the first roughs presented to a client, which are then worked up in colour by the designer or the illustrator.

Until fairly recently, the graphite pencil was

the most common medium for the quick visualization of images. Although fibre and felt-tip markers have by no means superseded the pencil, they offer a similar facility – and in colour.

QUICK COLOUR DRAWINGS

Markers are now immensely popular visualizing tools, widely used by graphic artists as a drawing or colouring medium for producing not only rudimentary roughs but also for first and finished roughs. The chief reason is their great convenience compared with alternative media such as watercolour or gouache: markers are quick to use, require no filling or mixing, and are available in a wide variety of tip types.

The leading manufacturer of colour markers offers more than 200 colour choices in both broad- and fine-tip pens, which are colour matched with papers, overlays and printing inks, thereby ensuring colour consistency at every design stage from roughs to printed material. A range of cold and warm greys (in 10 per cent gradations) is also available for monotone work and shading. Marker nibs are made with felt or fibre tips – with the less hard-wearing felt used, normally, for medium and broad lines and fibre tips for the medium and fine lines needed for fairly detailed work. Nib shapes vary from round and square to chisel (which gives both a broad and a fine line) and bullet shape (which gives a line with a rounded edge), and the markers contain either water-based or spirit-based ink. Spirit-based markers are colour-fast and have good mixing qualities, but they tend to bleed on ordinary paper, possibly giving a patchy coverage and causing the paper to cockle. For this reason, special marker paper should be used. Water-based markers do not bleed and, if desired, their colour can be applied in layers to

■ **Above** This bold, simple design shows how quick and effective marker rendering can be. The outline, probably roughed in pencil first, was done with a black marker before the colours were applied in broad sweeps. The logo and heading are rendered freehand with the text indicated by parallel lines.

1

2

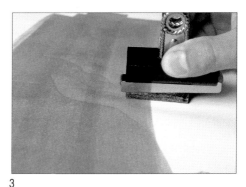

3

produce varying effects. The colour range of spirit-based studio markers – those most frequently used by professional designers – is more than 100; and these are ideal markers for presentation work. But be warned: studio markers are expensive and the nibs dry out if uncapped for any length of time.

Although markers are seldom used by illustrators for finished artwork, they are an attractive, convenient and useful 'painting' tool for rough visuals, whether these are representing illustrations, photographs or diagrams. The very nature of the marker means that it lends itself to being used quickly and in a fluid way, making it ideal for preliminary presentations when the design concept must be communicated economically but effectively. At this stage, the design is not finalized, so marker rendering should be loose to allow the idea to be further explored by everyone concerned with the look of the product.

FINISHED PRESENTATIONS

The marker can also be used for the finished presentation of an approved design. To produce a really professional finished visual, the artist needs to be highly skilled in marker techniques which, although not difficult to acquire, need practice and confidence to master. Linear work and linear and flat colour filling are not so dif-

■ Applying flat colour with markers

1 Cut the top off the marker with a sharp scalpel.
2 Using a pair of tweezers, extract the ink-soaked filling.
3 You can now use the marker pad to cover large, solid background areas. This is not only a quick and easy way to apply flat colour, but it also means that an even tone can be achieved and there are no brushstrokes.

1

2

3

4

■ Visualizing three-dimensional packs with markers

In this example, the client requested a lively design for a writing set. The designer took the theme of a gambling casino and used a croupier's dress sleeve and gloves as the container for the pencils, dice and so on. The presentation roughs were marker-rendered and consisted of several sheets showing the objects, as well as the pack.

1 The black outline of the pencil was done first.

2 & 3 Using a fairly thick marker nib, the background colour was quickly but roughly filled in, leaving the edges uncoloured.

4 The edges were then filled in using a fine-tipped marker. Main background colours are always rendered first before details and highlights. Make sure one marker colour is completely dry before applying another, otherwise smudging may occur.

5 The dice cubes were first drawn in pencil.

6 & 7 These are then coloured using a medium-tipped marker.

8 The dots are drawn in accurately with the help of a template and a fine-tipped marker.

9 & 10 Highlights are added with bleed-proof white gouache and grey drop shadow is added to enhance the three-dimensional effect.

11 A final rough is produced incorporating all the components of the design. From this a detail of the container can be made.

5

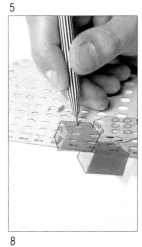

8

9

10

ficult for the beginner but fully realized drawings are. With a finished presentation, the marker may be the principal technique employed but it does not have to be the only one; fine lines may have to be drawn and other details rendered with pens, coloured crayons, paint and other media. The final effect can be close to a photographic likeness.

GUIDELINES FOR USING MARKERS

● Even, flat colour effects can be produced by removing the marker from its barrel or tube and using it on its side.

11

Simulating an illustrative style with markers

A highly-finished presentation rough can be achieved using markers as this example for a cassette design shows.

1 Using a fine-tipped marker, the cassette's outline is drawn up accurately with the help of templates.

2 & 3 Details are filled in with the same black marker using a rule and curves where possible and freehand where necessary.

4 The basic design completed, the drawing is now ready to be coloured in.

5 & 6 Using a fairly broad-tipped marker, shading is applied in confident strokes. A cloth slightly dampened with solvent helps to spread the tone evenly.

7 & 8 When the ink is dry, more colour is added and spread in the same way to create even, flat colour.

1

2

3

4

5

6

7

8

9 & 10 The grey highlights and shadows are carefully completed before the brown tones are filled in on the areas where the tape is visible.

11 A broad-tipped yellow marker is now used to fill in the remaining area of flat colour.

12 To soften the hard black marker line and enhance the grey sheen of the cassette case, white paint is used to obscure all but a faint outline.

13 Now all that remains is for the final details and highlights to be put in.

14 A white crayon is effective in highlighting small areas, as shown here.

15 & 16 For the final touch, the artist carefully draws in the letter A and adds a black drop shadow, which sets off the finished drawing most effectively.

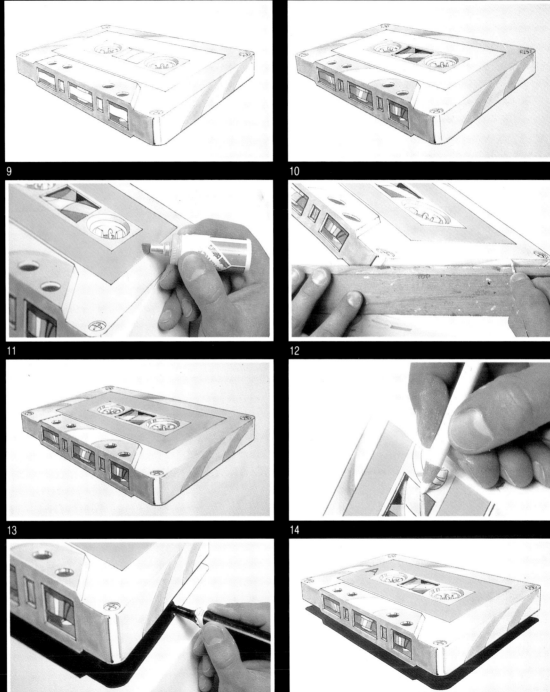

9

10

11

12

13

14

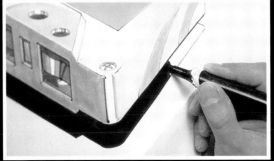

15

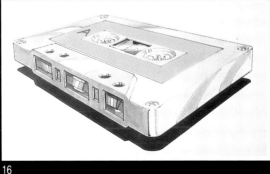

16

Right Markers are used in this storyboard rough to give vibrant colour and immediacy to the simple images and words, and to suggest a kind of childish spontaneity. Shading and highlights, however, have been carefully used to achieve these effects.

Below This marker rough has been taken to a high degree of finish. Details such as the fine calligraphic lettering on the cigarette pack have been carefully outlined before being filled in. Note the tonal effects and effective use of shading on the fingers.

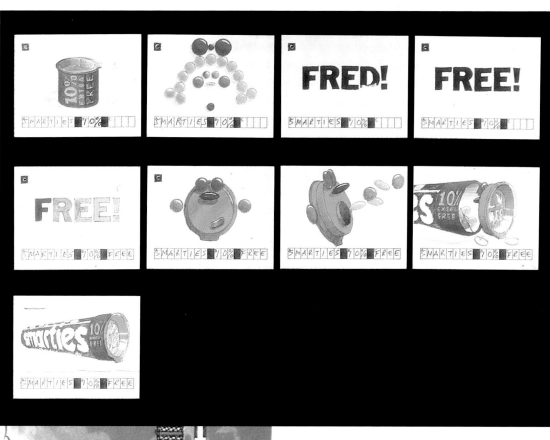

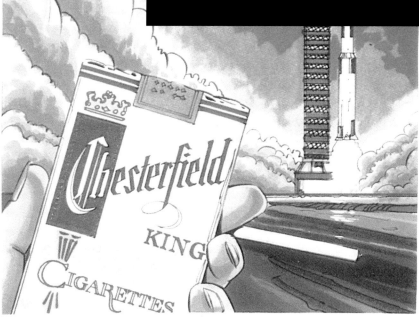

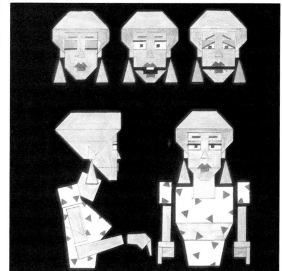

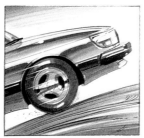
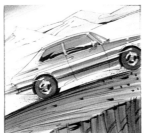

Left This finished storyboard rough for a car advertisement demonstrates the versatility of the marker. In the past, this slick metallic effect could only have been achieved with an airbrush.

The stroke lines of the marker have been used to good effect to create a sense of speed and maximum use has been made of shading and highlights.

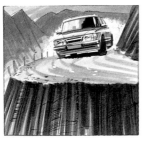
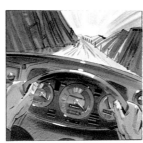

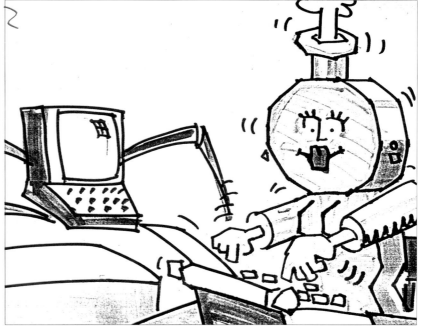

Left and Right These highly finished marker roughs rely on the novel use of lines and cubes to suggest their association with computers and computer graphics. Once the planes were accurately drawn, the marker rendering was relatively easy and is clearly the right medium to colour and soften the somewhat caricatured images.

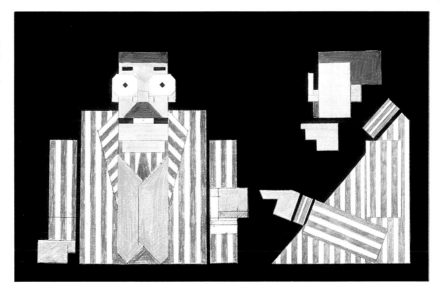

Above This deceptively simple marker rough is outlined in black with grey shading effects. It is a good example of the immediacy that can be achieved when the marker is used quickly and confidently by a skilled draughtsman to create a cartoon-like image.

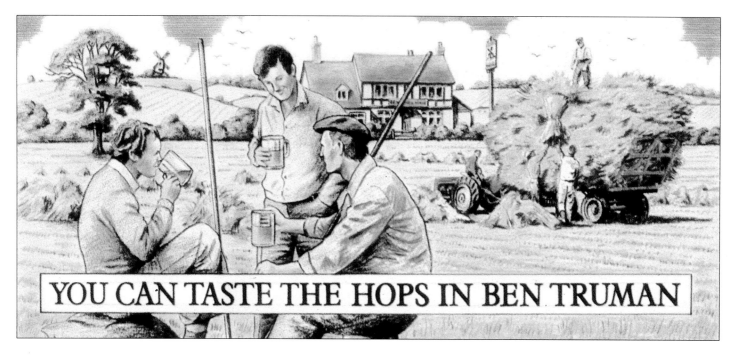

YOU CAN TASTE THE HOPS IN BEN TRUMAN

• Use spirit markers in combination with water-based inks by drawing in pen and colouring in with the marker; the marker does not cause the ink lines to smudge or 'bleed'.

• Lengthen the life of your markers by keeping them in plastic food storage containers to prevent the ink from evaporating, which can happen even when they are capped.

• Make your own colour chart showing how marker colours vary on different paper surfaces – for example, bleedproof, non-bleedproof and the reverse of sheets.

• Remember that certain colours can be combined with greys to give darker shades – to create shadows, for example.

SIMULATING AN ILLUSTRATIVE STYLE

Simulating an illustrative style for presentation purposes is not particularly easy, but it is a skill that the graphic artist generally needs to acquire –

▧ **Above** It is perhaps surprising that the marker can achieve detail as fine as on this illustration. All the outlines were first done in fine markers, the basic colours laid down and then worked over for details. The marker ink has been used to produce an attractive softness which is entirely appropriate for this rustic scene.

▧ **Right** Shading and highlights have been used effectively in this marker-rendered fashion illustration to convey the tone and texture of the fabric.

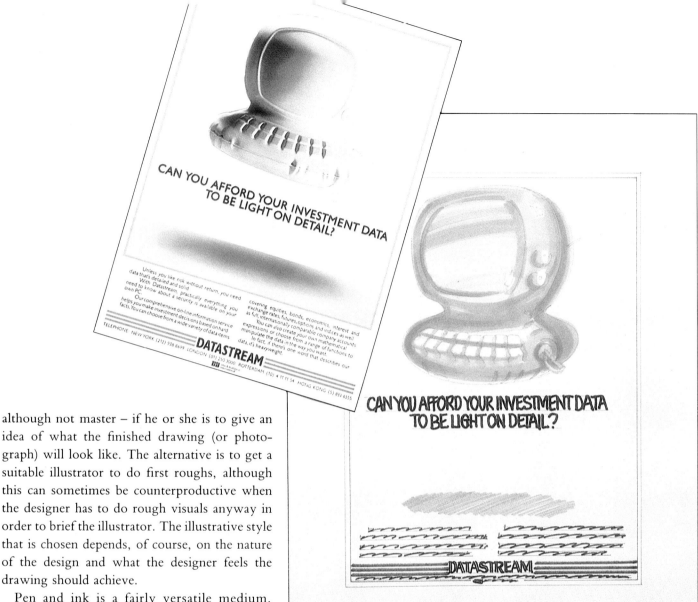

CAN YOU AFFORD YOUR INVESTMENT DATA
TO BE LIGHT ON DETAIL?

although not master – if he or she is to give an idea of what the finished drawing (or photograph) will look like. The alternative is to get a suitable illustrator to do first roughs, although this can sometimes be counterproductive when the designer has to do rough visuals anyway in order to brief the illustrator. The illustrative style that is chosen depends, of course, on the nature of the design and what the designer feels the drawing should achieve.

Pen and ink is a fairly versatile medium, capable of producing simple line illustrations or a wide variety of textures and tones. Traditionally used for caricatures, architectural drawings, single-colour book illustrations, anatomical or fashion drawings, it can be effective alone or with wash. Drafting pens, which have their own ink reservoir or cartridge and whose nibs come in a range of line widths from 0.13mm to 2.00mm, are the most suitable because inks for

■ **Above** The presentation rough for this uncomplicated design uses one marker colour for the inflatable computer, a fine-tipped marker for the headings and a wavy line for text. The finished advertisement hardly varies from the rough.

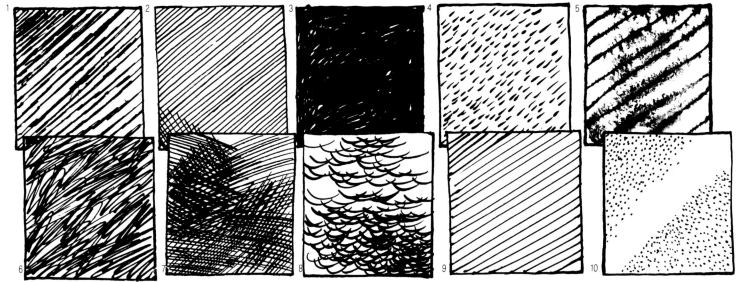

Above A wide range of effects can be achieved with pen and ink. Rough hatching (**1**) and freehand hatching (**9**) can create striking effects while cross-hatching in the corner (**2**) can intensify tonal values. A dense texture can be simulated by almost filling in an area (**3**). Jabbing lines (**4**) are used to create texture or background tone. To smudge lines (**5**) draw the pen across an area of wet paper so that the ink bleeds. A crazed line (**6**) can fill in an area giving the impression of depth. Hatching and cross-hatching (**7**) can intensify tonal values. Small curved lines (**8**) soften the effect of cross-hatching. Stippling (**10**) can express shadow, tone and texture.

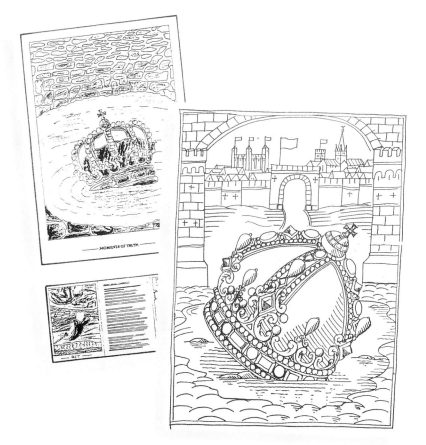

Left The art director's rough for this illustration established the basic theme and design of the drawing. In consultation with the illustrator, however, the composition was tightened so that the crown dominates the foreground, with a gateway and castle added as background. The result was a much more telling image rendered by the professional illustrator with considerable technical expertise.

1

2

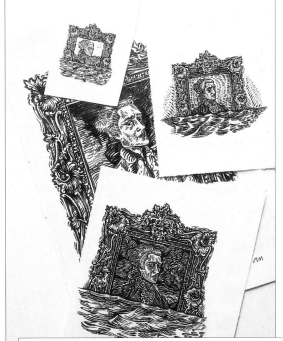

3

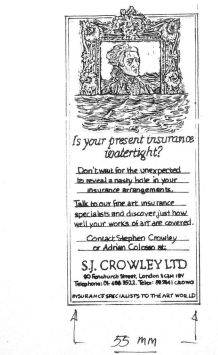

4

Simulating illustrative styles

The designer's brief was to produce an advertisement for an insurance company specializing in fine art which could be reproduced in three different sizes. The designer chose to 'adapt' an old master painting rendered in pen and ink.

1 The old master painting, plus frame, is copied in pen and ink onto tracing paper.

2 The rough is reduced, using a photocopier or PMT. At the same time, half the image is masked off so that only the figure's chest and shoulders are showing. Water is then drawn in with easy, confident strokes and the whole illustration retouched to get rid of ink blots or other mistakes.

3 The image will be reproduced on advertisements of three different sizes ranging from small to large. After the image has been reduced to the appropriate sizes, it is apparent that the background looks too busy on the smallest image. This is then whited out completely. To enhance the medium-sized image, the background is simplified, the water is extended to improve shape, and texture is added to the sides.

4 The presentation rough for the small advertisement shows how effectively the image has been combined with lettering.

them are available in a wide range of colours. Nibs recommended for the beginner are 0.2mm, 0.4mm and 0.6mm. Remember, too, that the paper should be receptive, being neither too rough nor too porous.

Rudimentary roughs should be as simple as possible to convey the idea rather than the actual illustrative style – which will, after all, be worked on by the illustrator. If you are a beginner, spend a little time practising with pen and ink until you feel confident with the medium and can achieve a fluent freehand style.

Watercolour is not a medium that the novice designer should tackle without practice, because it is the most uncompromising of the paint media. Watercolour on the paper is transparent and translucent. This means that every wash that is laid down (and there should be no more than three) can always be seen. Mistakes, therefore, are almost impossible to disguise. Choice of

paper (which must be stretched) is also important. Watercolour is frequently used in conjunction with pen or pencil drawings, and is most commonly employed for fashion and book illustrations. Although the wonderful translucent effect of watercolour is almost inimitable, the inexperienced graphic designer is better off using water-based markers for preliminary presentations before commissioning a professional illustrator to produce finished roughs in this medium.

Coloured pencils are a versatile medium and, like markers, are easy to use. There are basically three main types: those with thick, comparatively soft leads; those with harder leads, which are used for detailed work and small drawings; and water-soluble pencils, which can be used as ordinary pencils or in combination with water to produce washes of colour. Coloured pencils can create subtle tonal effects which markers cannot

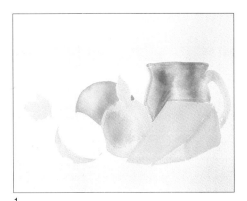

1

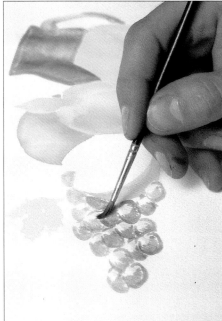

2

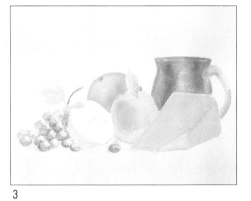

3

■ **Working in watercolours**
1 After the basic wash has been laid down on the paper, shaded washes in the different colours are applied working quickly from dark to light.

2 The grapes are painted in using an almost dry brush.
3 The finished watercolour has that soft, translucent effect which is almost inimitable in other media.

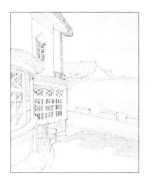

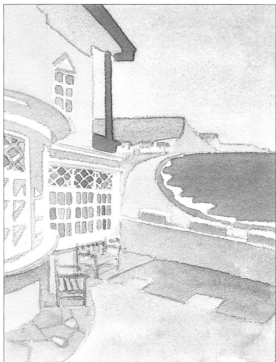

Above and Right This holiday brochure rough was done in very soft pencil. The fine watercolour illustration was subsequently produced for the final presentation to reassure the client that this was the right medium to get the soft atmospheric effect he wanted. Note that each colour is a single wash.

Left and Below The soft pencil rough and finished watercolour for this interior were produced for the same brochure as the pictures left. Again, the colours were applied in a single wash. Great subtlety of effect can be achieved with watercolour but it is a difficult medium for a beginner.

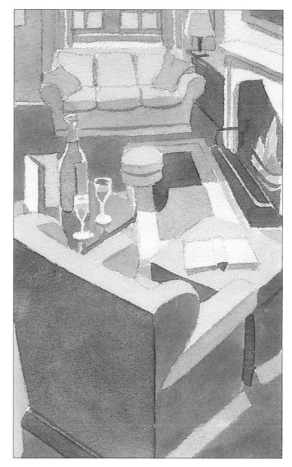

F r a n c e

Bnow burl bnl bnls iioiej fldfi lsi ful nb ve lwei n x l fo h , sobne l s io n bzx dlih lfnlisen fl ksd fgief dskasi skfi wenf slihlwf ndvbiatlixdnvlawie gn i l ili ln lhni fnlei lfnsf iusef n nf lxdkek oo le osndf oweo snvwre ufdli ndltind

Left This very simple grape design softens the relative starkness of the photograph. The leaf veins have been painted with a dry brush. The watercolour has been positioned on the layout with low-tack adhesive.

achieve so easily, and some can be used to give rich colour over large areas. Many can also be used on wood and textiles as well as on ordinary drawing surfaces. For many designers, the wide colour range and versatility of coloured pencils make them ideal for simulating an illustrative style, rather than employing more demanding media. One new type of pencil (Stabilitone) combines the qualities of a coloured pencil, a crayon and watercolour, so can be used for rough visuals in much the same way as a marker, as well as for more finished work.

RENDERING FLAT COLOUR

There are various ways of rendering flat colour on a presentation drawing. Markers probably provide the quickest and easiest method, but on a finished presentation, a medium such as gouache is sometimes more appropriate. Unlike watercolour, gouache does not rely for its effect on the glow of the paper showing through. Once the colours are mixed, large areas of flat, brilliant colour can fairly easily be laid with no brush marks showing. Coloured papers for pencil, crayon and pastel work are available in a wide range of shades. These provide areas of flat

■ **Above and Right** These simple but highly effective watercolour roughs for a *Farmer's Weekly* brochure were produced with single washes of different colours. The finished presentation, however, for the same client uses a gouache-rendered illustration (above right) which suggests a high-tech image which the client, after due consideration, decided he preferred.

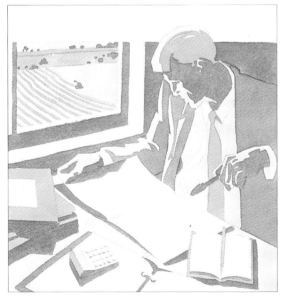

1

2

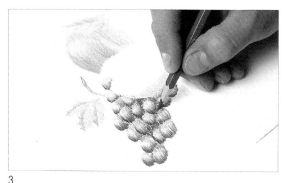

3

■ Simulating an illustrative style with crayons

Crayon is used here in much the same way as watercolour.
1 The images are softly outlined with the point of a hard pencil, then rough 'washes' of colour are laid down using the crayon at a flattish angle. Use paper or card to mask the illustration and spread the tone

4

in diagonal strokes.
2 Tone is gradually built up by shading in layers and leaving highlights.
3 Details are added last with the fine point of the pencil, as can be seen on the grapes.
4 The final rough shows the delicacy that can be achieved with crayons. The linear tonal effects are attractive in themselves and, in contrast to

watercolour, this is a relatively easy medium to work in.

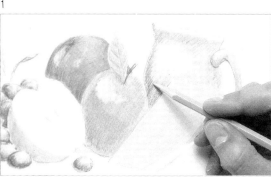

1

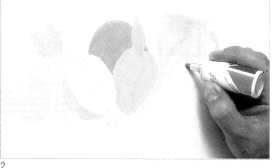

2

■ Using crayons and markers

Crayons and markers have been used together here to define the image more clearly and to achieve flatter colour.
1 The pencil outline of the image is erased so that only a faint guide remains.
2 Markers are used to fill in the basic background colours.
3 The tip and side of the crayon are then employed to define the line and add appropriate tone and details.
4 The final illustration shows how the crayon has been carefully and closely worked to produce more defined details and highlights.

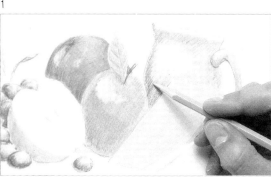

3

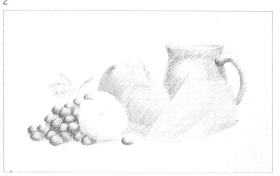

4

Left This presentation shows three alternative designs for Christmas wrapping paper. They were presented in this way because it creates the illusion of a whole sheet and saves the artist a lot of time. Crayons were used as they do not have to dry, there is no bleed and they can be applied on almost any type of paper or card.

Bottom left Water-soluble crayons have been used for this book jacket rough to simulate a watercolour.

Below Although markers have been used for part of this design for a letterhead, crayon is the main medium. It allows the artist far more control as the leads can be cut or sharpened to any width or angle, which also means that greater detail can be obtained.

■ **Above** This presentation was for a poster that will eventually be silk-screened. The technique was simulated by tearing pieces of coloured paper and sticking them down. Although almost child-like in its simplicity, a bold visual image has still been successfully created.

colour, as do other papers less suited to drawing but which will take air-brushed pigments, inks and markers.

The airbrush is used by professional illustrators not only for rendering flat colour but to achieve a remarkable variety of light, shade and tones so that the finished result looks like a photograph. To produce such precise, intricate work requires a mastery of the airbrush's sophisticated technique. However, using the students' or beginners' kits now available, the graphic artist can render flat colour and graduated backgrounds relatively easily. For producing graduated colours such as the sky in a finished presentation, the airbrush may be the only way to achieve the desired effect.

GRADED AND BLENDED COLOURS

The single–action airbrush is the simplest and cheapest type. With it the spray pattern can be altered only by changing the distance between the airbrush and the surface to be sprayed; this kind of airbrush is, however, perfectly adequate

■ **Above** Although felt-tipped airbrushes are extremely useful, they do not give the artist the same control or versatility as conventional models. And despite the fact that colour change is quick, felt-tipped pens hold only a limited amount of ink and soon dry out.

■ **Right** All sorts of attachments are available for use with a conventional airbrush. The nozzle cap can be replaced with a splatter cap to create the effects seen below right. Although not normally associated with artists, the ordinary domestic hair dryer is one of the studio's most useful tools – especially when the drying process has to be speeded up.

for the designer who only wants to use this medium for general background work. Beginners' sets come with a medium-sized nozzle and a can of aerosol propellant, as well as an instruction book. Gouache is probably the most popular airbrush medium, although concentrated watercolours, inks and acrylics are all also used by experts.

Felt-tipped fed airbrushes, which use a marker in place of a colour cup or reservoir, are useful because quick colour changes can be made without the need to clean the airbrush between each colour.

Even somebody who wants merely to master graduated backgrounds needs practice in handling and using the airbrush, and in masking. Background effects are achieved using a broad freehand style. The density can be gradually built up by adding more layers of pigment. Low-tack self-adhesive masking film makes the broad application of colour easier to control, and masking liquid is particularly useful for irregular shapes such as trees, where cutting a mask might be difficult.

With watercolour, the principles of shading a wash are the same as applying flat wash except that water is added to the colour on the palette as work progresses. The artist therefore works from dark to lighter shades. Because it is almost impossible to alter a graded wash once it is completed, the artist needs experience before trying this in a presentation drawing.

Drawing inks are useful for building up colour, not only on paper and board but also on synthetic surfaces, including plastics. Most are waterproof when dry, flow freely and can be mixed with each other and with water to create a wide variety of shades and tones. Graduated colour can be achieved by progressively diluting

■ The three illustrations on this page were ideas for various television cartoon characters. All the backgrounds have been created with an airbrush and they show just how important it is to get the background correct: the whole mood of each picture, whether light-hearted or deeply sinister, depends on how the background has been realized. Because these types of images are usually cut-outs or executed on overlays, the backgrounds can be stored and used again. This enables the artist to experiment with a variety of choices – which can also be discussed with the client – before making a final decision.

a rich initial mix as the wash descends, or by gradually adding more pigment to the initial mix. Water-based aerosol spray colour, although more suitable for applying flat or graduated colour to three-dimensional objects, can be used on drawing papers if care is taken and the colour applied sparingly.

USING 'FOUND' ILLUSTRATION MATERIAL

Collage can be an exciting way of adding interest to an illustration or drawing. In its simplest form, cut-out paper or fabrics can be added to

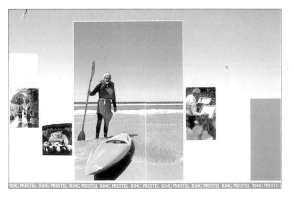
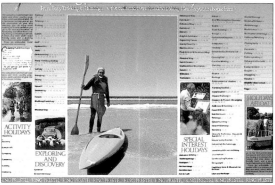

■ **Left** In a business where the
client inevitably wants
everything yesterday – and time
is money – speed is of the
utmost importance. To meet
these demands manufacturers
have produced materials that
can be used to create instant
art. The background of this
dummy spread for a holiday
brochure may look airbrushed,
but in fact it is a printed sheet
called Letratone. The artist has
then cut out existing material
from magazines and pasted it
down. The type was
reproduced photographically
onto an acetate overlay, to
complete the presentation.

■ **Right** For this company logo
the lettering will eventually be
airbrushed. However, for the
rough presentation it is not
necessary to spend hours
airbrushing the whole lot.
Present the client with the line
work along with just an
individual letter showing how
the finished image will look.

■ **Left** This book cover was a
very prestigious job for the
studio it was given to because
the contents of the book hold
what is considered by many to
be the best of European
illustration. The designer had a
fascination for Victorian social
maps, so his aim was to
translate this concept into
modern terms.

provide flat colours or instant textures. Alternatively, if the pictorial image is bold and uncomplicated, cut-out coloured papers or other materials can be used to create the entire picture. Collage is particularly appropriate when the designer wants to create within the design the tangible effects of a particular texture, such as the roughness of coarse canvas or the smoothness of metal foil, or if he wants to use the 'spontaneous feel' of collage to create an impression of freshness and vitality.

Photographs from magazines and newspapers can also be used to good effect, depending on the nature of the design. The design for, say, a new lawn mower or piece of garden furniture can be superimposed on a magazine tear sheet of a garden. Architects frequently superimpose drawings of an intended building onto photo-

graphs of an existing site, or introduce trees, vehicles, figures and so on from magazines or photographs to enliven the image of a line drawing. An existing photograph can also be used in a preliminary design to give an indication of the final effect without going to the expense of producing finished artwork.

CREATING TEXTURES

Textures can be hand-rendered on a drawing or illustration by using various techniques appropriate to the media employed. This is, however, time-consuming and most designers will, if possible, choose from the wide range of instant dry transfer textures that are available.

TECHNICAL ILLUSTRATIONS

Technical illustrations are produced by architects, engineers and product designers and basically have two functions. The first is to give an impression of what the object or building looks like, and the second is to give precise information about its size and shape as an aid to construction. Different geometric techniques are used for each, and a mastery of them is essential for the designer working in these fields.

ISOMETRIC PROJECTION

The first roughs for presentation should obviously give an idea of what the object or building looks like. One of the easiest and most attractive ways of doing this is to use isometric projection, a three-dimensional illustration constructed on 30° parallel lines. One advantage is that all parallel lines are drawn to their true length or in scale, so measurements can be taken from the finished drawing. Isometric grid paper printed with vertical lines and 30° lines makes the job particularly easy. The only disadvantage is that

■ **Above and Left** These three examples show a dummy cover and spreads for a book. They were all made up from existing material, which gave the client an idea of the style rather than the actual content.

■ **Right** This visual for a record album sleeve for Virgin Records is an interesting example of how an image can be created out of a multitude of different styles and media. The face of Mike Oldfield is made up of crayon, gouache and ink, while the background consists of hand-made papers and collage.

1

2

■ Technical illustration

1 & 2 The initial line work for the illustration of this car is traced from a photograph before any of the detail is added. All the lines of one angle are put down first, starting from the left and moving across to avoid smudging. In this case the artist is left-handed so he starts from the right.

3 Beginning at the top and working down, the horizontal lines are drawn in the same way.

4 & 5 The artist now adds any details that can be drawn freehand, before moving onto the outer curves, which have to be accurately constructed with the help of French curves.

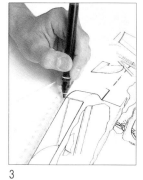

3

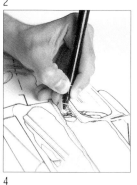

4

5

6–8 Here we can see that the car is already taking shape. The addition of the inner curves shows how the car is gradually built up after each stage.

6

7

8

9 & 10 The ellipses are now drawn in. When doing this it is always best to use two ellipses: place one underneath the one that you are using so it is slightly raised from the surface. This prevents any ink from seeping underneath and smudging.

9

10

11

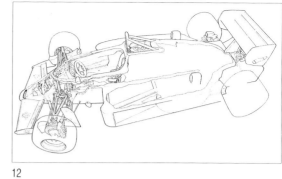

12

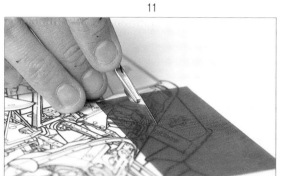

13

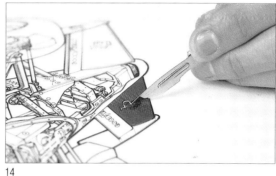

14

11 & 12 Any depth or shading is added by cross hatching, which is simply a series of small lines drawn close together.

13 & 14 Tints are added in Letratone – which does not need rubbing down – so the area can be cut around and the excess peeled away easily. The small details that should not be covered are too tiny to cut accurately. This means that the artist has to scratch them out carefully with the tip of a scalpel.

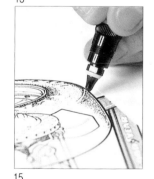

15

15 & 16 Finally, any components which have a soft finish – for example the rubber tyres or the velvet steering wheel – are simulated by stippling. This is done freehand using a technical pen to produce a series of dots.

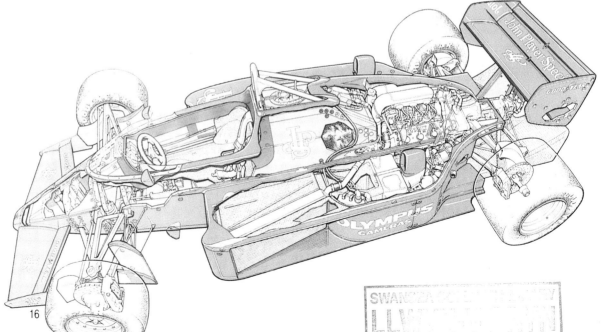

16

the object can appear slightly distorted, although this rarely causes difficulty with clients of technical products, largely because they are so familiar with the technique.

AXONOMETRIC DRAWING

Another method using parallel grid lines, employed widely by architects, is the axonometric paraline drawing. Whereas the isometric projection gives equal emphasis to all three visible surfaces, the axonometric drawing, with a 45°-45° oblique, has a higher angle of view and the horizontal plane receives more emphasis. (A 30°-60° oblique also has a high angle of view with one vertical plane receiving more emphasis than the other.) For architects, an axonometric drawing is easier to construct than an isometric one because ordinary plan drawings can be traced to form the basis of the drawing. Paraline drawings, whether freehand or drafted, are very effective pictorial illustrations, easily understood by most people. For this reason, they are widely used in presentations of all kinds, but particularly for large-scale shopping or building complexes where the client wishes to attract a range of buyers or tenants.

The drawings can, of course, be rendered in a variety of media. Airbrushing is a popular technique with product designers but markers, coloured pencils, watercolours or a mixture of media can be used, depending on the degree of finish needed for the presentation. Some designers even make a feature of the grid lines in their roughs. Remember, too, that paraline drawings can be a quick and effective means of showing ideas for jobs – such as exhibition designs – that involve spatial elements, before models or detailed plans are made.

CIRCLES IN PARALINE DRAWINGS AND ELLIPSES

Arcs, curves and circles form a major part of many drawings and it is surprising how many designers and illustrators rely on templates to do these for them when, in fact, they are fairly easy to construct. Circles in paraline drawings appear as ellipses but they are not true ellipses because they are constructed around four centres (using two sets of radii and a compass or circle template) so that they are slightly shorter on the major axis and slightly longer on the minor axis. Circles in perspective drawings, on the other hand, are true ellipses. It is easy to draw small ellipses freehand: first draw a box, then outline the ellipse ensuring that it touches the box at the mid-point of each side. Alternatively, the tram-

■ **Right** The most important consideration in this project was the fact that the design would have to adapt to anything from a shop front to a badge for employees – so simplicity was the key. Continuity was also a prime factor to be borne in mind. For instance, note how the 'screw' detail – at the front of the shop – has been made a focal point and carried through to the interior, creating a sense of fluidity.

mel method of drawing an ellipse, which is relatively quick, easy and accurate, can be used.

PERSPECTIVE DRAWING

Perspective drawing is the most common form of pictorial illustration. It does not have the optical distortion of paraline drawings and more than any other kind of drawing represents reality as we usually perceive it. For this reason, it is widely used in presentations of all kinds. The ability to draw perspective quickly is a skill every designer should have, but the means of acquiring it can be daunting to the beginner.

One-point perspective is the simplest kind and is used to show head-on views such as interior spaces, some street scenes and axial arrangements. It is relatively easy to construct but often results in dull and lifeless views. However, it can be particularly exciting when used in sequential drawings to create an almost cinematic illusion of walking through a space. Two-point perspective is probably the most commonly used perspective

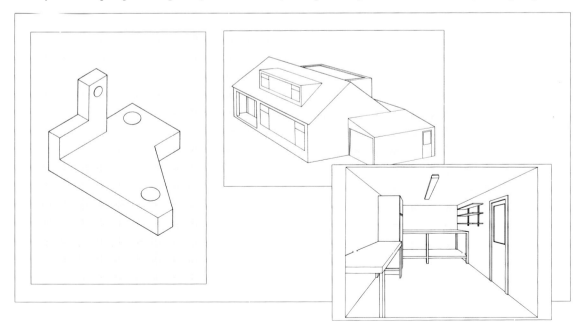

■ **Left** These illustration grids enable the graphic artist to make technical illustrations without using a lot of equipment and entering into complicated mathematics.

■ **Above** The architect has made his flat plan of an interior more interesting by adding pieces of furniture.

drawing and portrays objects that are at an angle to the viewer. It is appropriate for both exterior and interior views.

The rules for constructing linear perspective are complex and even when they have been mastered, experience in perspective drawing is all important. However, various perspective aids such as printed grids and special drawing boards can take much of the sweat and time out of drawing.

It is very important to make perspective drawing seem alive. This means that the viewpoint must be a believable one – although not necessarily the most obvious one. It can be higher or lower than eye-level, and often the challenge for the presentation designer is to find the viewpoint that most enhances the object or building. Another problem is that beginners usually try to show too much in a composition. Even a finished presentation drawing should never be cluttered with unnecessary detail – it is worth bearing in mind Matisse's technique, which was to begin by drawing or painting a detailed picture, then in successive stages gradually simplifying it by stripping away all but the essential elements.

ORTHOGRAPHIC PROJECTION

Orthographic drawings, which show flat views of an object's plan and different sides, are the primary tool of architectural draughtsmen. They give precise information about size and shape so that the object or building can be constructed from them. Usually three planes are drawn – front, horizontal and profile – although in complex designs all six planes can be included. Third-angle is the most commonly used projection with the horizontal and profile views drawn in the same relationship to the front view as they are in real life. The horizontal is drawn above and

the left profile to the left. Drawings are done in scale to enable the finished object to be constructed. Architectural plans, cross-sections and elevations are all forms of orthographic drawing – and although some people have difficulty in 'reading' orthographic projections, they form a necessary part of most architectural presentations because they show the precise nature of the design and can convey technical information about it. Orthographic projections are conventions, but many historical and modern examples have been so exquisitely presented that they have become valuable works of art in themselves.

DIAGRAMS

Diagrams convey information about a product and are a necessary part of many presentation designs. They can be entirely schematic as are, for example, the maps of the London Underground or Paris Metro systems, or they can incorporate pictorial elements, as cutaways and cross-sections frequently do. Cross-sections, which show the layers or levels of an object or building can obviously be very detailed when, say, the geological layers of the Earth's crust need to be shown. For presentation purposes, such a diagram would be roughed out in fine pencils or markers to show the precise information required before the final artwork was embarked upon. Cutaways also allow the inner workings of an object or part of it to be seen and often give a simultaneous inner and outer view of the object's form. A flow diagram to show, for example, how the internal combustion engine works, is a four-dimensional diagram indicating also changes in time and space. Similarly, 'operational' diagrams are four-dimensional in that they show the mechanics of the object and how it is assembled or connected. The highly effective exploded drawing – which shows how the parts of an object fit together by drawing them hovering in space around the object – is a kind of operational diagram. So is the less conventional 'compressed' drawing where, say, the components of a pencil form a concertina within the outline of the object itself. The various manufacturing stages a pencil goes through during its production can be compressed graphically into the form of the pencil itself.

Narrative or step-by-step diagrams can also show how things work or are assembled, and these are frequently used in a quite straightforward way to show how domestic appliances are operated. Pictograms, in which pictorial images are incorporated on graphs, charts or maps, are another way of enlivening visually commonplace graphics. All these are usually done in some detail – although not necessarily with great finish – for presentation, simply to convey the required information.

▌**Below** Because of the complexity of some technical illustrations and the fact that they have to be 100 per cent correct, the initial roughs are often executed in pencil. Any alterations can then simply be rubbed out. This example shows the specifications of a vintage car.

Film and photographic techniques

PHOTOGRAPHS ARE USED INCREASINGLY for visuals in a design largely because they look slick and also because many clients specifically ask for them. For presentation purposes, it can be inexpensive if the designer takes his own photographs. Tear sheets from magazines or transparencies borrowed from picture agencies are also an effective and cheap way of showing the client the *type* of photographic image you aim to achieve.

Sometimes, a designer cannot always achieve the same high quality results as a professional photographer. However, most graphic artists do know how to use a 35mm camera and it is quite easy to learn the effects that can be achieved by using planned lighting and different lenses. If you *do* take your own photographs and want successful results and a minimun amount of time wasted, remember these two points: don't over-complicate the concept or content of a shot, and keep the lighting simple. Fashion and advertising photography, however, need to be very slick and if you are working in these areas, it is wise to employ a professional – even for a one-off presentation.

Photographers usually, but not invariably, specialize in different areas. There are photographers' agents and printed directories that can guide the designer to a suitable person – although, in practice, most graphic artists have their own contacts. It is important that the photographer knows precisely what effect is to be achieved; and, if appropriate, make sure he or she knows all the limitations imposed by type areas, gutters, folds, and so on. The budget should, of course, be agreed in advance.

All designers use film and photographic techniques for presentations, not only to copy, enlarge, reduce or manipulate pictorial images and type, but also to simulate the appearance of the printed design. In many instances, this involves the use of reprographic techniques such as screens, textures and tints.

COLOUR PRINTS

There are basically three types of colour print available from photographic studios: C-types, R-types and cibachromes, the only difference between the last two being the process and the material printed on.

C-type prints are made from either a negative, an internegative (made from a transparency) or a copy negative. They can be hand- or machine-printed, although hand printing allows greater control over the colour balance as well as over the crop and size of the print. A high-quality print can be produced from a hand-printed C-type, but, with modern processing techniques, the R-type colour print is almost as good. The advantage of the C-type is that large, good quality display prints can be produced and any number of prints can be made from the interneg – although this may not be of interest to the designer of a presentation who wants a one-off

print. Another advantage is that an interneg, once made, can be used for further or final presentation prints after the original transparency has been returned to, say, a picture agency.

The R-type print is produced directly from the positive transparency or the artwork and it is probably the most popular technique with designers of one-off presentations. The quality is only slightly cruder than a C-type, and the colour balance may be altered by shading the printing paper with an appropriate filter. It is a relatively inexpensive process and, in most instances, more than adequate for presentations.

The relatively new cibachrome colour print uses a 'dye destruction' process, in which the coloured dye layers are incorporated into the paper structure and unwanted areas of colour are destroyed during processing. This is another direct colour copying method, and prints can be made from transparencies, flat artwork and even small packs. Generally, cibachromes produce brilliant, clear colours (although, unless processed by hand, not necessarily true colours). In common with R-types, they tend to produce high-contrast results, which can, of course, mean loss of detail. Small three-dimensional objects can be directly copied, and this is an extremely useful facility for presentations.

Because the light is fixed, however, results are not like those produced in a photographic studio. Cibachromes are particularly suitable for exhibitions and displays because they do not fade like C- and R-types, but for ordinary presentations they provide brightly coloured prints on paper that will not crack when folded. Like R-types, they can be quickly and inexpensively produced. The cibachrome process (with minor variations) is available

■ **Above** Colour prints of the same transparency show the differences in quality of the respective colour printing techniques. The C-type (left) generally produces the most faithful results. The R-type (centre) is slightly cruder and the colours lack the intensity of the hand-printed C-type. The cibachrome (above) produces a high-contrast print but with a proportionate loss of quality in the tones.

under different trade names from a wide range of photographic suppliers. One of the best known, syndicated worldwide, is Chromacopy.

One or two of the larger manufacturers of reprographic equipment now produce PMT machines capable of making full-colour copies from any colour original. These machines use special negative and positive film, and the entire copying process can be completed in a matter of minutes. Results tend to vary. Bright, high-contrast subjects work rather better than others. Colour correction can be carried out but involves more time and materials (which are expensive). On the whole, the coloured PMT is often a hit and miss affair unless the designer uses reliable equipment, knows what he is doing and is prepared to spend time and effort in getting the correct result.

Colour photocopies produce extremely crude reproductions with very degraded colour values. Although they are useful for colour reference material, their quality is too poor for them to be used for presentation purposes except when rudi-

mentary roughs offering different options or positional changes are to be shown. An advantage is that photocopy paper folds easily, whereas colour prints do not.

Polaroids provide instant, high-quality colour material but have only limited application in the presentation itself. They are, however, extremely useful when artwork or illustrations are being prepared for a presentation, because they can provide quick colour reference for figures, objects, and so on, which can be traced off.

For design studios that do a lot of finished presentation work, the omnichrom or 'imaging system' is a worthwhile investment. The omnichrom is a mechanical alternative to hand painting on cells. In the imaging system, multicolour images are made directly onto sheets of white plastic paper or clear film using inks that, when dry, are sensitive to ultraviolet light. A simple colour takes only a few minutes to process using the kits supplied. The advantage of the system is that the designer can complete the whole job

himself without having to wait for prints to return from an outside supplier. Some specialized studios provide this service for those who do not want to undergo the expense of buying the kit.

BLACK AND WHITE PRINTS

Black and white images (and, indeed, final artwork) are usually photographically reproduced for presentation in a PMT machine. Few designers are unfamiliar with this most versatile aid, which can enlarge or reduce, reverse images from black to white or left to right and produce screens as well as images on cells. PMT machines produce excellent quality line origination and will print on reversal, gloss or matt paper as well as acetate (although the paper is very expensive). Halftones can be reproduced using a regular dot screen or a line screen, and special effects can be achieved using screens such as denim, concentric circles and mezzotint. All these are perfectly adequate for most presentations, but the quality is not as good as that produced in specialized houses.

Photocopiers can be used to produce reproductions of the design idea or elements of it. In theory, the photocopier is capable of producing copies of text and typescript, photographs, illustrations, artwork in line, solid, halftone or colour, the outline or surface of a three-dimensional object (a hand, or one side of a packet, for example) and copies of colour prints and transparencies. In practice, however, results vary not only according to the quality of the machine but also from manufacturer to manufacturer.

There are two basic types of photocopying process. A thermal copier uses special paper and, for that reason, is somewhat limited in its application. The alternative electrostatic method can print on any paper, including coloured and tracing papers and even onto transparent film (which is useful for overhead projection transparencies). This flexibility makes it the most popular method.

The designer needs to have access to a copier with A3 as well as A4 page size format and one that is capable of reduction and enlargement.

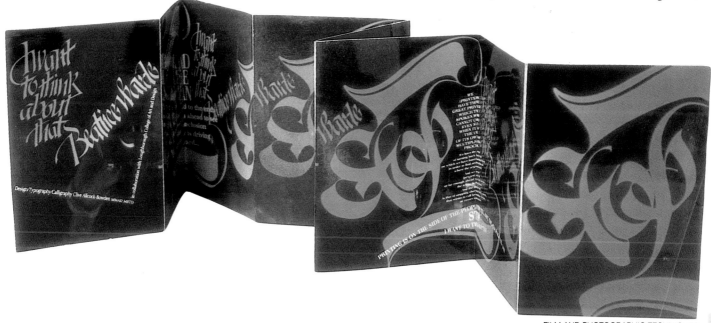

■ The omnicrom process

1 & 2 For this project, which will eventually be used for the front cover of a book dummy, an initial rough was made which was also used to work out all the specifications.

3 & 4 For the omnicrom process all the individual colours have to be isolated and drawn up on separate sheets. Any areas – in this case, lettering – that are to be printed must be blacked in, as this is what the machine will pick up.

5 The white lettering had to be on a red background so it was copied onto coloured|paper.

6 The photocopy is then sandwiched between the omnicrom transfer paper. This consists of two layers: a paper backing with a transfer sheet on top. These transfer sheets are available in any number of colours.

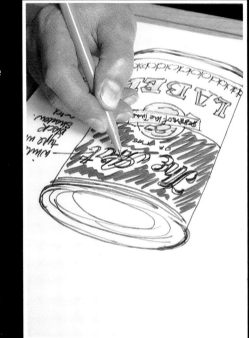

1

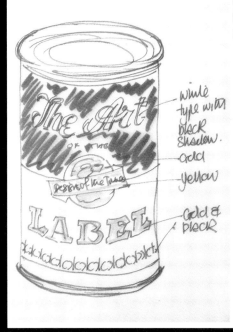

2

3

4

5

6

7

8

9

10

11

12

7–11 The sheet is then fed through the machine, which produces the coloured lettering instantly to a high standard. This process is repeated for all the separate colours.
12 The outline of the can is then drawn in black line. Because the overall background will be of a graduated blue tone, the outline is photocopied onto Letratone paper.

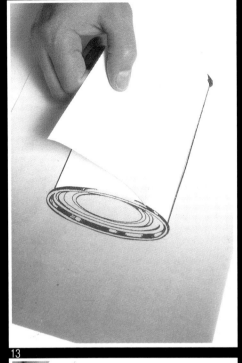

13

14

15

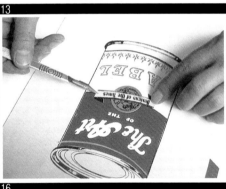

16

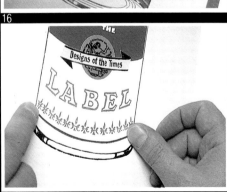

17

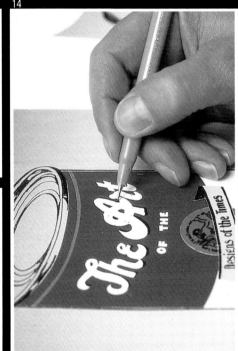

18

19

13–19 The centre of the can is cut out, as this will make positioning slightly easier. The following sequence of pictures shows how all the individual components are added and spraymounted into place. (Always start with the larger components, moving gradually towards the really minute awkward pieces.) Finally, any outlines or small details are added with a fine felt-tip pen.

20 Although this process might seem very time-consuming, you can see by the end result that a very professional and highly finished presentation has been achieved.

21 This example is of a presentation for Christmas wrapping paper. It was chosen to show just how versatile and useful an omnicrom machine can be

20

21

IT'S NICE TO KNOW THERE ARE STILL SOME THINGS
YOU CAN ALWAYS RELY ON.

IT'S NICE TO KNOW THERE ARE STILL SOME THINGS
YOU CAN ALWAYS RELY ON.

SO GOOD...

...YOU WON'T EVEN

KNOW WE'RE THERE

SO GOOD...

...YOU WON'T EVEN
KNOW WE'RE THERE.

■ **Left** A photocopier can help to produce very effective first roughs when the visuals consist of simple line work. These examples contrast the preliminary roughs (where straightforward line illustrations were photocopied and positioned on the layout) with the finished roughs (consisting of typeset text and cut-out colour photographs and artwork).

■ **Left** Type or line illustrations printed on coloured paper in the photocopier can be a cheap and effective way of enlivening visuals for a presentation.

Some of the more expensive models can do this in increments of one per cent from 65 to 146 per cent, and many can reproduce in red, brown and blue as well as in black, which is a particularly useful facility.

What the designer wants from a photocopier is a clear, sharp copy of an illustration or text. Text is normally not a problem if the original is sharp and well-defined, and the quality of reproduction is usually high. However, illustrations do pose a problem, particularly when considerable tone and linear details occur on the original. Many line illustrations come out very well, and indeed, by altering the definition on the machine, some can actually be improved in sharpness. Black and white and colour photographs and screened material from magazines, newspapers or books are gen-

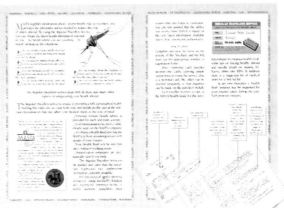

■ **Left** The preliminary roughs for this brochure cover and sample spread make use of instant lettering, parallel lines and line illustrations. The originals were photocopied, then stuck onto layout paper, after which colour was added. The printed brochure shows how the basic idea was developed and improved upon in consultation with the client.

erally low in quality when reproduced, although some Japanese copiers are better than others with tone illustrations.

Newly developed products have recently enhanced the quality of photocopied material. A self-adhesive plain paper, for example, can be used on pack mock-ups, and a clear, overlay sheet printed with a fine white dot screen can be used to improve the quality of photocopied photographs by minimizing that bleached look.

Facsimile (fax) machines can provide an instant electronic link between the design studio and the client, whether they are in the same city or in another continent. Design ideas and rudimentary roughs can, therefore, be circulated for approval or comment in the time that it takes to make a telephone call. Fax machines, which are available in A3 or A4 formats, produce a stitching effect when conveying type and line illustrations, and this can be used as a special design feature. Tone drawings can also be processed through the fax machine, but generally the quality of reproduction is poor. Fax machines can considerably accelerate the design process, particularly in the early stages when ideas and concepts are still being discussed, but they are generally unsuitable for more advanced presentations unless the design involves only type and line as, for example, in a newspaper advertisement.

REPROGRAPHICS

The graphic artist simulates or employs reproduction techniques for two reasons. The first is to give an exact impression of what the design

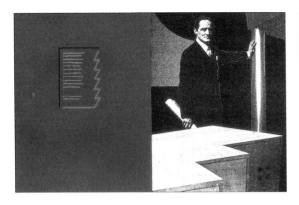

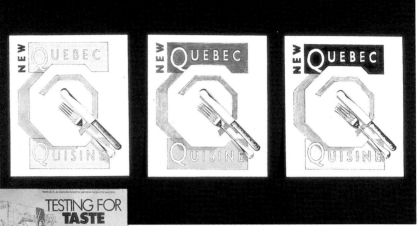

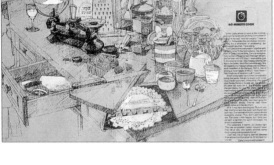

Above The photograph here has been photocopied to achieve a high contrast that is intentionally different from a faithful photographic reproduction.

Right The illustration and text for this spread have been photocopied onto sepia to obtain a 'farmhouse kitchen' feel. Details were then gone over with white paint and soft colours to achieve the final effect.

Above right The basic image for this letterhead was photocopied three times, then hand-touched and coloured to produce these different effects.

will actually look like when it is printed in a magazine, book or newspaper – a critical factor with some jobs and therefore a necessary part of the presentation; the second reason is to produce special effects by using wavyline, mezzotint and other screens that are outside the conventional dot and line range.

Screens can be coarse or fine depending on the quality of the paper to be used in the final reproduction. The rougher the paper, the coarser the screen required. If the presentation design is for newspaper reproduction, the number of lines per inch on the screen can be as low as 55 or 65; however, typical colour reproduction in magazines and books uses 130-150 lines per inch.

There are three ways in which the graphic artist can convert continuous tone into clear dot screen, line screen or special effects halftones. By far the easiest is to use instant dry-transfer sheets. These produce percentage dot and line tints as well as graduated tints, straight line and perspective line tints. Dot sheets, plus oblique and circular lines are also available, and all can be used singly or overlaid to create moiré or other interesting patterns. Special effects textures, mezzotints and white tints as well as colour tones are also included in the range. This gives the designer a wide choice and a chance to experiment with overlays for different effects.

Black and white screen conversion can, of course, be done in the PMT machine. The important thing to watch here is the screen size in relation to the reduction or enlargement of the original. If, for example, the original is 6×9 inches but will be reproduced in a magazine at 4×6 inches with a 130 lines per inch screen, the original is half up. The screen should also be half up – that is, coarser by one-third to allow for this – at 90 lines per inch. Depending on the original, screened PMTs are of reasonable quality and probably good enough for first presentations. However, should first-class quality halftones be

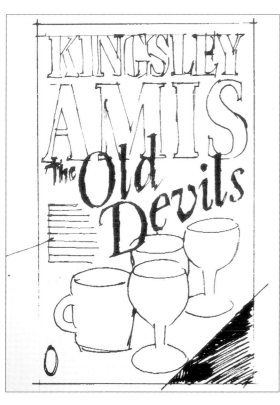

These two line designs show the reproductive quality of the fax machine, which can form part of the design appeal should the designer so choose.

Below For the first presentation this photograph printed on a matt surface was coloured in with crayons. For the final presentation, the designer used a professional colouring artist to achieve more fine, glowing colours.

wanted for a final presentation, it is best to go to a specialist house – the cost is usually warranted by the high definition produced. Specialist houses also provide combined screens using line and dot to define, say, a car, and mezzotint for its background setting.

Mezzotint, a line conversion screen giving a stippled effect, is popular in advertising. Simulating a mezzotint is very difficult to do by hand and, although available in dry transfer sheets, the results can be somewhat coarse. To give the real impression for a final presentation, it is cost effective to get this done by a specialist house.

ALTERED IMAGES

The graphic artist may want to alter photographic images for two reasons. One is simply to get rid of blemishes or scratches on an original to produce a better quality picture. This frequently needs to be done to material provided by photo-

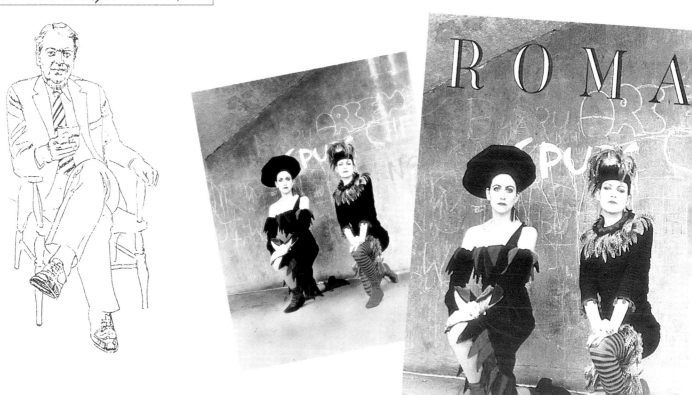

40 Line – 25%
Concentric

40 Line – 50%
Concentric

40 Line – 75%
Concentric

65 Line – 25%
Concentric

65 Line–50%
Concentric

Denim

Mesh

Weave

Twill

Burlap

60 Line – 25%
Wavy Line

60 Line - 50%
Wavy Line

60 Line – 75%
Wavy Line

Oval

Flake

Fibril

Ring

Walnut

Cherry

Birdseye
Maple

Coarse 25%
Mezzo Tint

Coarse 50%
Mezzo Tint

Coarse 75%
Mezzo Tint

Fine 25%
Mezzo Tint

Fine 50%
Mezzo Tint

White Oak

Walnut Swirl

Basswood

Red Oak

Basketweave

Parquet

40 Line – 25%
Straight Line

40 Line – 50%
Straight Line

40 Line
Crossline

Herringbone

■ **Above** Some of these
screens can be used on
presentation illustrations to
create special effects.

■ **Right** The screen in this
illustration is a combination of
dot and line.

graphic agencies. The other reason is to produce special effects. Most retouching is done by specialized studios, particularly when the original is a transparency or a precious negative. However, it is not uncommon for a designer to retouch black and white and even colour prints for presentation purposes.

When retouching black and white prints, it is important that the image should be reproduced on matt paper that hasn't been coated with plastic (which is a difficult surface to retouch). The paint used can be gouache or a special retoucher's paint, which is guaranteed not to show up or to be affected in subsequent reproduction processes. The surface can be lightened, darkened or defined using a fine brush. Black flecks and marks are often scraped off with a scalpel blade. Hand colouring is done in a similar way, although if a tone image is to be worked up, it must be a fairly weak print – again on matt paper – to begin with.

Colour prints can also be retouched with the same materials as black and white prints. Air-brushes are frequently used by professional

the creation of manipulated photographic images for advertising reproduction.

Special effects can be achieved with the slide sandwich, in which one transparency is superimposed over another. Both images should be simple and uncluttered to achieve the right dramatic effect. The reverse of this is the double exposure where the dark areas of one transparency must be opposite the light areas on another. With photomontage, two transparencies are very accurately masked so that, when superimposed, the desired effect is achieved. This is frequently used to produce startling, surreal images in advertising that hitherto had to be done as illustration.

SIZING AND·MARKING UP PICTURES

Sizing pictures and artwork is very important, both when commissioning artwork or photography for presentations and also when handing over work to be done by a specialist studio. Normally, illustrators prefer to work at a larger size than that of the proposed reproduction – usually half or twice up. This has the added advantage that the reduced version will be much crisper. When colour prints are required, the flat artwork should be sent out with an overlay in place with any areas of the picture to be cropped shaded out. The vertical and horizontal dimensions to which it should be reduced should also be indicated on the overlay.

The overlay is equally important with transparencies. It should include a trace of the image, with crop lines and the dimensions ruled and indicated. The designer may wish to cut out, say, the background in the image or to cut into another image. In these instances, the specialized studio must be given very clear instructions together with a full-size layout showing a trace of the images as they should be reproduced.

■ **Above** In this photomontage two transparencies, each showing the descent of a solitary parachutist, are superimposed.

retouchers to mask out some areas or highlight others. It is wise to hand over expensive colour prints to specialist studios, unless there are only small bits and pieces to retouch.

Colour prints may also be retouched by the dye-transfer process, by which colour is added using water-based dyes and removed using chemical bleaches. The colour bias of the original transparency can be corrected and a complete change of colour in one or more parts of the image can be achieved. Obviously, this needs to be done in a specialized studio, and the print passed to a dye transfer retoucher to effect other changes, such as removing or highlighting parts of the image. Both the processing and retouching of dye transfers are very expensive, and their use is mainly restricted to

■ **Sizing up a photograph**
1 Secure a sheet of tracing or layout paper over the image. Rule a box around the required area and trace the outline.
2 In the left-hand corner trace the size of the box in which the image has to fit and draw a line through the diagonal.
3 Place over the original image and secure.

The printed message

▌ Hand embossing

1 Trace or draw the letter or shape required onto paper that is secured with masking tape to a baseboard. (It is important that the baseboard is thick enough so that when the top layers are removed a definite indentation will remain.)

2 Cut out the letter with a scalpel following the pencil line and cutting into the surface of the baseboard. Then remove the tracing paper.

3–5 Carefully following the scalpel lines, cut through the top layers of the baseboard to make a clean indentation. Peel away the letter and tidy up the indentation with a scalpel.

6 Position the paper to be embossed face-side down over the baseboard, making register marks with masking tape so that it can be positioned exactly.

7 Burnish gently to create an even indentation on the paper.

8 Remove the paper and turn it over face-side up to see the raised, embossed letter.

9 The embossed letter most effectively simulates the real thing.

FOR RUDIMENTARY AND FIRST ROUGHS, the graphic artist often simulates printing techniques. But for finished roughs, it may be necessary to imitate these techniques more exactly or to employ the printing process itself. In many instances, it is really advisable – and cost effective – to get specialized printing done by a professional. Local printers and stationers can provide good results with blind embossing, hot-foil stamping and thermography and many

printers will make up bound dummy books (with blank pages) if you are a regular or past customer. There are also one or two companies that specialize in producing one-off, superbly finished presentations to the designer's specifications. These range from relatively simple low-cost jobs to expensive productions, including packs (mostly for the advertising industry) which are far superior in quality to the actual printed job. There are, however, some tech-

1

2

3

4

5

6

7

8

9

niques that the graphic artist can do himself or simulate without too much difficulty, if he has the time and inclination. Embossing is one and rubber stamping is another.

SPECIALIZED PRINTING TECHNIQUES

Blind embossing is formed by squeezing a sheet of paper or board in a press between a set of moulds – one female, one male – usually made of brass or steel. A fairly soft type of paper or board produces the best results. A local printer will often do this type of work relatively inexpensively, but the original design should not be too finely detailed or the embossing will not retain it. When high quality and fine detail are required, a special four-pillar embossing press must be used, so it is worth checking with the local printer or specialist house whether they have access to such a press or if they can give sharper detail (usually at greater expense).

Die stamping is a type of embossing with colour involved. An intaglio engraving is made into a hardened steel plate. Coloured ink is applied to the recesses, the surface is wiped clean and the ink is 'pressed' out onto the surface – producing a raised glossy image on the inked side and a slightly engraved impression on the other.

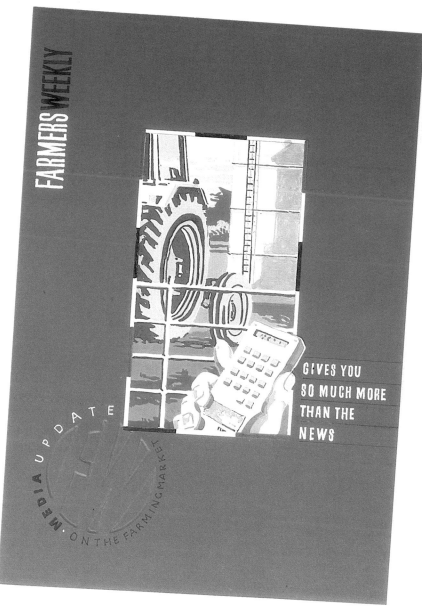

Above This presentation rough for the cover of a *Farmer's Weekly* report makes effective use of an embossed seal. Note that the letter design is fairly simple. The one-off embossing technique outlined opposite is not really suitable for an image that requires finer details. Thermography or blind embossing – both done by specialist houses – would be more appropriate choices.

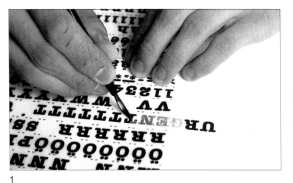

1

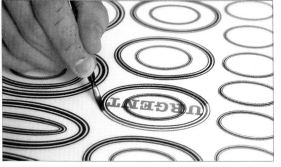

2

4 Dab a small piece of cotton wool in white paint. Use this to break up the image here and there since rubber stamps never produce a perfectly inked image.

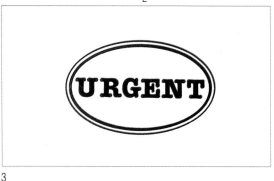

3

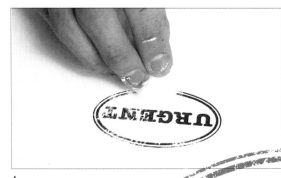

4

■ **Simulating a rubber stamp**
1 Use instant dry transfers for the letters, words or symbols on the stamp. Burnish the dry transfer lettering onto a sheet of paper.

2 & 3 Place a sheet of dry transfer ovals over the lettering and choose the appropriate size. Position over the letters and burnish into place.

Die stamping is carried out by specialist printing houses, but it is expensive and the range of colours is limited. Colour matching can therefore be difficult when, say, subtle colours are to be printed on the same sheet. Die stamping is really necessary only for the exceptional, prestigious presentation where a high-quality effect, rather than cost, governs the embossing technique used.

Thermography is an inexpensive way of simulating die stamping. The 'embossed' matter is printed with a special non-drying ink, then dusted with a special powder which adheres to the wet ink. The sheet is then heated causing the powder to melt. When dry, this gives a raised image but, unlike die stamping, there is no indented impression on the reverse side. Local printers and stationers regularly use this technique for letterheads and business cards, and will work from a designer's own artwork at little or no extra cost.

Hot-foil stamping is another technique readily available from local stationers and printers. Foils in a range of colours – but usually in metallic silver or gold – are printed down by means of a heated disc in a similar way to bookbinders' gold blocking. Again, this is not very expensive to get done professionally, although the graphic artist could simulate the same effect for, perhaps, a first rough by using instant rubdowns in gold or silver or painting the image in gold or silver ink or paint.

Rubber stamps are easily made from the graphic artist's artwork, although if this is being done by a local printer it is necessary to specify precisely what you are aiming to achieve. A simulation of a simple rubber stamp design can, however, be done using instant dry transfer

5

5 Copy the rubber stamp design by PMT or photocopier so that the white paint is not visible and use as appropriate.

shapes (ovals, squares, triangles etc) and lettering. A rubber stamp rarely produces a perfect outline, so to break up the dry transfer shape, use a small cotton wool pad with white paint to dab out the solidity of the line at irregular intervals. Type positioned within the shape can be similarly broken up if desired. Alternatively, photocopy your design several times to degrade the image, adding white paint in places to further break up the edges.

Pinholing is another printing technique that the designer can easily simulate, although the surface must be one that will take the point of a fine or stout pin cleanly.

Silk screen printing is a familiar technique to most graphic artists from their student days and, although it is perfectly possible to screen print by hand for presentations, the majority of designers give the job to professionals with up-to-date

Making up a spread for a dummy book

The designer's brief was to make up a dummy for a proposed book on *Dressage*, using existing illustrative material from published sources.

1 The designer draws up the page dimensions on layout paper and begins to rough out the design of the spread.

2 & 3 Some of the existing picture material is boxed, so the designer traces the box sizes and outlines the images within the boxes.

4 Dry transfer instant lettering was the choice for the heading. The guidelines on the instant lettering transfer sheet have been used to help lay down the heading and these are now removed from the layout sheet with (low-tack) masking tape.

5 & 6 The dummy text has been typeset to size with real sub-headings but with Latin text for the remaining blocks of type. These text blocks are cut out and laid in position on the layout. Alternatively, instant lettering could be used for the sub-heads and Latin text; this is less expensive but slightly more time-consuming.

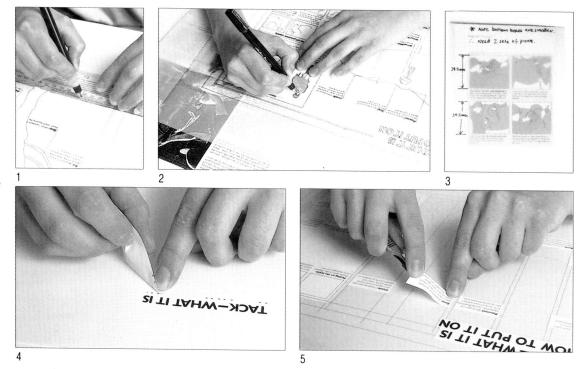

equipment. It is used principally for corporate identity presentations when the same logo may be used on tee-shirts, shopping bags, display posters, and so on. Screen printing's versatility is its great advantage because prints can be made on a variety of surfaces. Origination costs are low, as are printing costs for short runs. Although it is possible to produce four-colour halftones, it is really best suited to line printing of flat colour or when printing white on coloured or metallized board.

Basically, screen printing is a process in which ink is squeezed through a cut stencil which is fixed to a mesh screen, tightly stretched on a frame. The ink is forced through the mesh in the open parts of the stencil by a squeegee drawn across the frame from one side to another. Various fabrics can be used for the screen, such as silk, nylon or cotton, and synthetic fibres have

now virtually replaced natural ones. The stencil which is the pattern for the finished print can be hand cut or produced photographically. Manufactured knife-cut stencils can be cut directly from pencil layouts of artwork, and these are especially useful for the presentation designer, although sophisticated photo-stencils are widely used in commercial screen printing. Either of two photographic methods, direct or indirect, can be used to produce photo stencils. In direct stencil printing, the film positive or drawing is directly transferred to a screen coated with light-sensitive emulsion. Light hardening of the emulsion occurs in the non-image areas, leaving soluble emulsion in the image details of the stencil. These areas are washed out with water. Indirect photostencils are prepared, exposed and washed out or developed before the stencil is fixed to the screen.

6

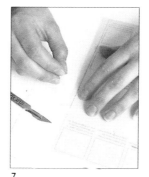

7

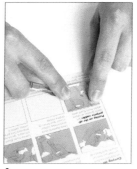

8

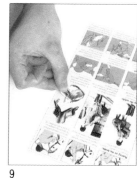

9

10

11

10 An instant line border enclosing the spread is positioned, rubbed down in the normal way and burnished for a secure bond.

11 The annotation lines are drawn in by hand using a fine-nibbed drafting pen.

12 With the dummy spread now completed, colour prints can be made if more than one copy is needed.

7 To give background colour to the blocks of pictures and type on the right-hand page, dry transfer instant tone is added. Use a clear plastic straight-edged rule to lay this down smoothly and slowly so that no air bubbles form. Trim off the excess tone with a scalpel and discard.

8 The boxed pictures are then cut out and a suitable adhesive applied to position them on the layout. A scalpel and steel rule is used to trim the pictures to fit.

9 The remaining illustrations are cut-outs which the designer has made with a scalpel blade. These are now laid down and positioned.

12

Foliage House Plants

Lorem ipsum dolor sit amet, consectetu eiusmod tempor incidunt ut labore et dol enim ad minim veniam, quis nostrud ex oris nisi ut aliquis ex ea commodo cou dolor in reprehenderit in voluptate velit dolore eu fugiat nulla pariatur.

Lorem ipsum dolor
laborum et dolor fuga. Et harumd derwu liber tempor cum nobis eligend optio co maxim placeat facer possim omnis vol repellend. Temporibud autem quinusd necesati atib saepe eveniet ut er repudiar earud reruam hist entaury sapiente del asperiore repellat. Hanc ego cum tene si eam non possing accommodare nost ro tum etia ergat.

Ut enim ad minimim
upidiiat, quas nulla praid om undant. orcend magist and et dodecendese vi ne sanos ad fusitium, aequitated fides t est cond qui neg facile efficerd posai vel fortunag vel ingen liberalitat m solen sib conciliant el, aptissim es mming null sit cuas peccand quaer t sine julla inaura ubile. Concupis plusque in insup molument oariunt iniur. Itaque r ptabil, sed quiran cunditat vel pl e and tuitior vitam et luptat pleni m improb fugiendad improbitate uaea derata.

Endium caritat praesert
necessit atib saepe eveniet ut er repudiar earud reruam hist entaury sapiente dele asperiore repellat. Hanc ego cum tene si asperiore repellat. Nos amice et nebevoi, ol cum conscient to factor tum poen legun neque pecun modut est neque nonor int cupidiat, quas nulla praid om umdant. coerocend magist and et dodecendese vi bene sanos ad fusitium, aequitated fidet fact est cond qul neg

Nequa hominy
cum omning null sit cuas peccand quaer explent sine julla inaura autend inane u desiderable. Concupis plusque in insup rebus emolument oariunt iniur. ipsad optabil, sed quiran cunditat vel pl propter and tuitior vitam et luptat pleni egenium improb fugiendad improbitate cuis. Guaea derata micospe riuneren gi quam nostros expetore torem tamet eum ipsum neque facil, ut n Lorem ipsum dolor sit amet, consectetu eiusmod tempor incidunt ut labore et dol enim ad minim

Lorem ipsum dolor sit amet, con tempor incidunt ut labore et dol veniam, quis nostrund execitati commodo consequat. Duis aute

et iusto odio digmissim qui bland exneptur sint occaecat cupiditat deserunt mollit anim id est labor distinct. Nam liber tempor cum t

Temporibud autem quinusd et ar ere egnufand sint et molestia non delectus au aut prefer endis dol quid est cur veroor ne ad eum int

cum conscient to factor tum pe pecun modut est neque nonor i nulla praid om umdant. Improb dodecendese videantur. Invat

conatud nother vl effeccri, et of bui tunning beaevolem sib com cum omning null sit cuas peccan explent sine julla inura autend in

Lacy Leaf Ivy
coerced magist

Variegated Needlepoint Ivy
invat igitur vere

Needlepoint Ivy
dodecendese vide

Canary Island Ivy
improb pary minuts

dermen Ivy
potus inflamed ut

■ **Left** A relatively easy and generally cost-effective way of presenting a dummy spread for a book or brochure is to use a background photograph onto which text and headings can be positioned. Usually the photograph is commissioned or, of course, the designer can take it himself. The important thing is to make sure that the photograph is composed in such a way as to conform to a predetermined layout. This means that the photographer must know the dimensions of the spread, where the gutter falls and the precise area allocated for text. When the enlarged colour print is made from the transparency, it is then a simple task to drop in the dummy or real print, including captions and annotations.

DUMMIES AND BINDING

Real or simulated dummy books or booklets are frequently appropriate for finished presentations, particularly when the client needs to get the co-operation of sales managers or co-edition publishers who frequently want to 'handle' the product for bulk and weight – especially if it is to be mailed – and approve the suggested binding. Dummy books or booklets can be either hand made or produced by a printer.

Often a printer's blank dummy will be supplied on request if the client/designer is a regular customer or the job is large enough to make it worth the printer's while. Page dimensions, the number of pages, the thickness (bulking quality) of the paper and its surface (matt or glossy) must all be specified before asking the printer to make up a dummy – as must the cover boards and type of binding if the book is to be hard bound. And should the book or booklet use coloured paper, 'art' paper for inserted illustration plates, or a fairly unusual material such as plastic-coated paper, these must obviously be part of the made-up dummy. A printer's dummy should, in other words, be identical to the finished work, except that the pages are blank. With a wrap-around finished presentation jacket, plus separate inside spreads showing text and pictorial matter, this makes the ideal dummy book presentation. However, with printing and binding costs becoming increasingly more competitive, printers are nowadays rather more reluctant to supply free blank dummies than they were in the past.

1

2

3

4

5

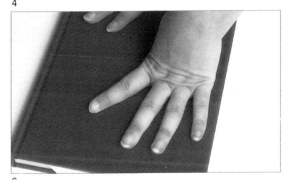

6

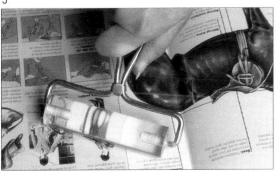

7

8

Making up a dummy book

For this presentation, the graphic artist intends to show the dimensions and bulking quality of the book, plus one sample spread and a proposed jacket.

1 A bulking dummy of the exact dimensions, paper weight and extent of the proposed book has been supplied by the printer. However, when the dummy pages are added, sheets have to be removed from a centre section of the printer's dummy to maintain the correct bulking quality. As a rule of thumb, for every page inserted remove three. In this instance, because two pages (one spread) are to be inserted, six must be ripped out.

2 The centre fold of the sample spread is scored with a blunt instrument, such as the back of a scalpel.

3 & 4 The spread is folded and tested for fit before a central wedge is removed from the top edge of the spread to help achieve exact centring and perfect alignment.

5–7 The crease is sprayed or waxed and pressed into position. Only one side is flattened with a roller; the facing page will be flattened when the book is closed.

8 The pages are now trimmed exactly using a scalpel and steel rule on a backing board placed between the leaves.

The same is true for the 'printed dummy' used for large or prestigious book projects. With this, the client/publisher provides black-and-white artwork (text and pictures) plus colour separations for, say, a signature (section) of 16 or 32 pages. A limited number of signatures are printed and sets of these gathered together to make up the book's extent. Fifty or more copies of what is then known as a repeat-section dummy are then bound and used for selling or promotional purposes. This is not an option open to many designers and a production of this kind of dummy relies on an understanding between the printer and client, who together are confident that their mutual and not inconsiderable investment will pay off.

More often than not, the graphic artist is obliged to make up his own booklet or brochure. Although these are not normally of great extent, getting the page size exactly right on all sheets is paramount. Many guillotines (paper cutters) and rotary/rolling trimmers (the safest to use) are now capable of cutting quickly and accurately through a variety of materials, including thick board and even wood and metal. Access to such equipment makes the job immeasurably easier. Handmade dummies should, of course, be made with material as close as possible to the finished article. As with printers' dummies, bulk and weight are important factors. If the brochure is to be a mailing shot, it is crucial to get the exact weight and no more; paper manufacturers are invariably helpful in this respect.

Rather than do the job themselves, many designers employ a local printer to make up the dummy. It is of course vital to be specific about what is needed and to discuss with the printer what he can and cannot do, particularly in the way of binding.

1

2

3

4

Making up a dummy brochure

When making up a dummy brochure it is important that the weight and number of pages are the same as the finished product. In this example, a rough cover was produced plus one spread.

1 The dummy cover and blank pages are roughly cut to size, leaving a five-centimetre border all round, and the centre fold of the cover and pages are scored with a blunt instrument. Because the brochure is to be bound with staples, dividers are set at staple-width and pushed through the fold of the cover and pages. In a brochure of this format, three to four staples will be needed.

2 The staples are pushed through the holes.

3 The dummy is turned over and the staples flattened with the end of the dividers or a steel rule.

5

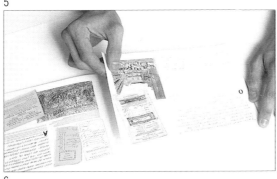
6

BINDING METHODS

There are four main methods of binding and these differ according to the nature of the book or booklet being produced and the materials being used. The bindings used for magazines and booklets are probably the simplest for the designer to simulate or get done at lowish cost by a printer.

In saddle stitching, the most common form of binding, the booklet or magazine is opened over a metal 'saddle' and stapled along the back fold by a staple machine from above. This can be done by the graphic artist using a long-reach staple gun, or by hand – the staple is inserted into holes made with a pin then bent to close – or quickly and cheaply by a local printer. Side stitching is used for thicker magazines, pamphlets and booklets. Wire staples are inserted through the front to the back of the booklet the required distance from the back edge. The disadvantage of this method is that the pages do not lie flat when the booklet is opened.

Perfect binding is used extensively in the production of paperbacks and many magazines. The folded sheets are roughened down the spine so that the binding glue adheres more strongly. A lining is placed over the backbone and the cover glued firmly in place. This is fairly easy to simulate using conventional adhesive glue, but again this is something that a local printer or stationer will do for relatively little cost.

Hardcover books or booklets are thread sewn, as are some paperbacks. Each signature of, say, 16 or 32 pages is sewn at its centre fold by machine and then the gathered signatures are sewn together. The sewn back edge is coated with glue and then rounded (on a special machine) to allow the book to open easily. A strip of gauze is glued to the backbone so that it overlaps on each side. A cloth cover is then attached before the book is placed in a casing machine which pastes the end papers and fits the hard cover. This is the strongest and most expensive form of binding. It can, of course, be done by professional binders and may be necessary for some final presentations despite its expense.

Mechanical bindings are used mainly on manuals and notebooks and occasionally on booklets. Here, holes are drilled through the covers and pages which are then bound together with wire or plastic coil, or with a wire or plastic comb. The great advantage of these methods is that they allow the book to lie absolutely flat when opened. For presentation purposes, these bindings can be done professionally or in the studio using a special machine. Although mechanical bindings are not particularly expen-

1

2

■ Ring binding

For larger design studios, or indeed the individual designer who does a lot of report work, it is well worth investing in a ring-binding machine. This will always give a professional look to a presentation and also, of course, to the finished job; and it saves the time, rather more than the expense, of doing this outside.

1 Set the machine to the pages' dimensions and to the number of rings to be inserted. Insert the pages for the holes or incisions to be cut.

2 A second process inserts the plastic rings through the pages and neatly secures them.

sive for one-off presentations, on a long print run the cost per unit is relatively high, a factor the designer needs to consider before specifying these simply for effect.

Ring binding, another open-flat method, is a loose-leaf form of binding. This is rarely used for commercial books or booklets, but is often used to show or present designs, artwork or textual material. Pages or sheets can be inserted or removed at will. The plastic slide binder is another inexpensive loose-leaf method. The triangular-shaped plastic slide, which comes in a variety of colours, lengths and thicknesses, grips the sheets firmly (and so the pages cannot be laid flat). The slide binder can be a useful presentation aid if technical details or research material is a necessary adjunct to the visual presentation of the design. Appropriately designed acetate or laminated covers can enhance the appearance of such material so that it becomes an integral part of the presentation 'package'.

MAKING UP A DUMMY BOOK

The designer produces material for the inside of a dummy book in more-or-less the same way as he produces camera-ready artwork for the printer. Either real or dry transfer dummy text can be used for body text and crossheads, with black-and-white bromides and colour prints for illustrations. Ideally, spreads for the book's interior should be produced as flat artwork, because fixing type and pictures in an already bound book puts undue strain on the binding. One way of reducing bulk is to produce a PMT of all line work; one can then add dry transfer colour headings to the PMT, as well as prints in black and white or colour. To reduce bulk even further, carefully remove one or two backing layers from the prints.

■ Right This example shows how for some presentations expense is only a minor consideration. Here the designer had to present his proposed plans for a new bridge to some very high officials. For a project of this nature a large amount of written information is usually required; although in this case it was executed only on a typewriter, a special binder was commissioned from a printer.

■ Left Rather than make a dummy book containing spreads, an alternative is to mount each spread separately and fix them at the top rather like a flip chart.

■ Above This spread has actually been placed into a dummy as the client wanted to see exactly what it would look like in the book as well as wishing to view the outside cover.

Working in three dimensions

PACK DESIGNERS, product designers and arch-itects habitually work in three dimensions, but most graphic artists are inexperienced in this area of design and feel uneasy when confronted with it. This is not without reason – because it needs different design skills to those of two-dimen-sional work and requires a familiarity with basic construction materials and methods. But rather than be viewed as daunting, this should be regarded as a challenge, because working in the round gives the designer a unique opportunity of extending his or her skills to create satisfying tangible objects. For presentation purposes, simple packs and models are not difficult to make, and it is only for some final presentations or when the pack construction is complex that the designer may need the help of a construction specialist or professional model maker. This is because in most instances the designer is not involved in the design of the container itself – which is usually one of a number of conventional types – but in its surface graphics.

■ **Constructing a simple card box**
1 A rough plan of the box is drawn freehand to work out the layout of the planes. It sometimes helps to dismantle an existing box to see how this is done, and then adjust the dimensions accordingly.

1

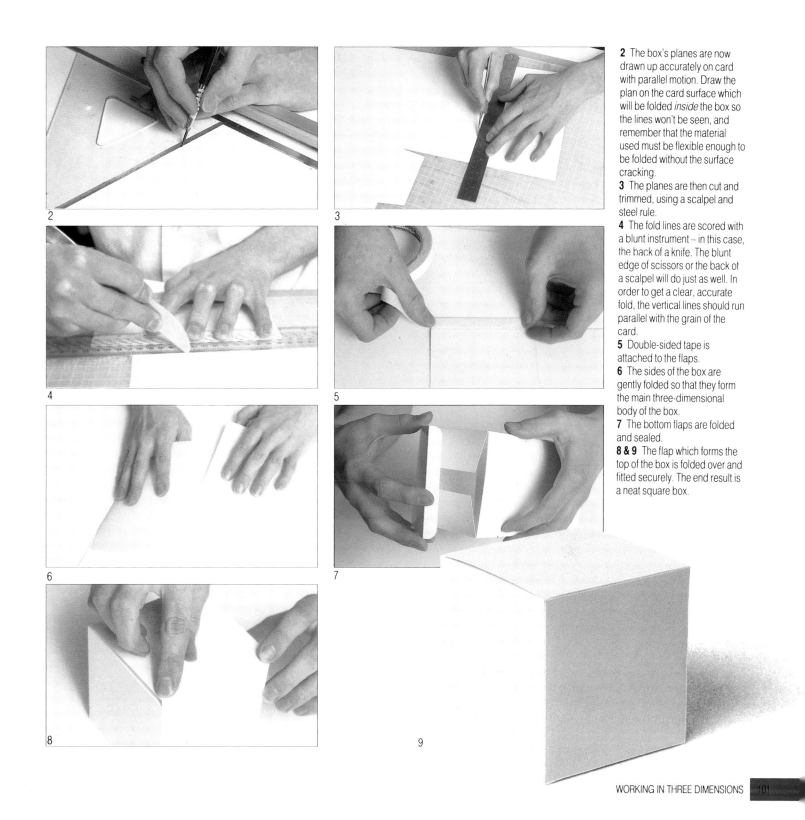

2 The box's planes are now drawn up accurately on card with parallel motion. Draw the plan on the card surface which will be folded *inside* the box so the lines won't be seen, and remember that the material used must be flexible enough to be folded without the surface cracking.

3 The planes are then cut and trimmed, using a scalpel and steel rule.

4 The fold lines are scored with a blunt instrument – in this case, the back of a knife. The blunt edge of scissors or the back of a scalpel will do just as well. In order to get a clear, accurate fold, the vertical lines should run parallel with the grain of the card.

5 Double-sided tape is attached to the flaps.

6 The sides of the box are gently folded so that they form the main three-dimensional body of the box.

7 The bottom flaps are folded and sealed.

8 & 9 The flap which forms the top of the box is folded over and fitted securely. The end result is a neat square box.

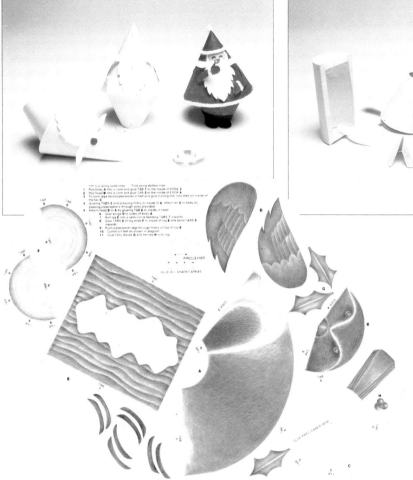

The quality of fine detail colour printing is not high with the latter process. In theory mock-ups for presentations should be constructed from material of a type similar to that finally adopted, but for early presentations paper or board, proprietary bottles and cans and foamcore cut to shape will generally serve the purpose. Paper and card is immensely versatile because it can be used not only for plane surfaces but also for curved ones such as cylinders and cones.

THE BRIEF

With pack designs, the client is usually quite specific about what type of container best suits his product. He will also often provide the designer with detailed research material which outlines the marketing facts – the kind of consumers who buy the product, how often they purchase it, and so on – and the performance of competitors. At the same time, he will discuss in general what kind of new image his product needs to increase its sales in the market place. Last but not least, the designer will be asked to work within a given budget. All this forms the basis of the design problem and must be

■ **Above** The rough for the Christmas log and robin was highly finished, produced on card and included printed instructions for assembling to show the client how easy it was.

PACK MATERIALS

The basic materials commonly used in package design are paper and board, glass, metal, and plastics of various kinds. The material used determines the method of printing it and this will affect the design, so it is important to consider the material from the outset. Most cartons and labels are printed by lithography, whereas foil or plastic film is often printed by flexography (which can print six colours on some machines).

considered carefully before even preliminary roughs are started.

Once first roughs and possibly a simple mock-up have been approved by the client, the designer produces final roughs and scaled or full-size models of the pack. Occasionally, he will be asked to produce a pack (either full-size or giant-sized) for advertising purposes – that is, for photography, a television commercial or an exhibition. This, of course, needs to look as good as, or even better than, the printed-up pack and because the budget for this type of work is often quite substantial, many designers prefer to hand over the job to a specialist house which produces one-offs to high-quality standards.

PAPER ENGINEERING

Paper or cardboard engineering is a term usually associated with collapsible pop-up books, greetings cards and show cards, but strictly speaking can be applied to any construction in card or board, from the simple to the very complex. Basic box containers are relatively simple to make from carton board, which is specially produced to be creased or folded without cracking the surface. One of the simplest

ways of making a box is to dismantle an existing one of similar shape and size. This shows how the planes are cut and folded, so that the designer need only trace round the flat shapes and scale his sketch up or down to get the exact size required before cutting out and assembling the box.

The pack design will already have been worked out on layouts, and it is optional whether the graphics are applied directly to the surfaces of the box or on separate sheets of paper or film. The latter can be attached with low-tack adhesive, making the graphics removable if corrections have to be made after the presentation. Needless to say, the visuals should be applied while the planes are flat, before the box is folded and made up.

With collapsible pop-up structures, an element of the design is automatically pulled forward to give a three-dimensional image when the card or book is opened and, in the case of a show card, then locked in position with struts on the back. Simple pop-ups are not as difficult to make as one-offs for presentation; and they are highly effective in greetings cards and in, for example, property advertising brochures. Children's pop-up books, immensely popular half a century ago,

■ **Left** In the roughs for this rather novel pop-up gift book, only three elements of the design 'pop-out' – the drinker's head, his arm and glass and the champagne cork. It was therefore not particularly difficult to construct as a one-off presentation. For the final product, however, the designer worked closely with a paper-engineering expert.

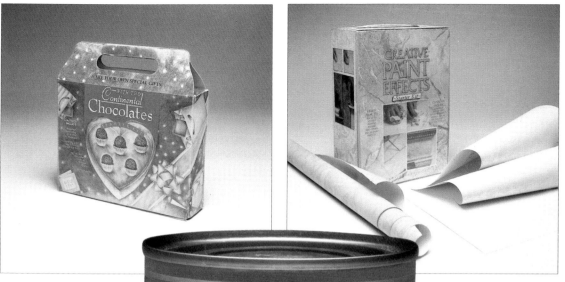

■ **Left** These two pack shapes are really quite simple to construct. Most pack shapes do conform to an easy basic structure but if in doubt, take apart an existing container and work from that.

■ **Right** Cylinders, too, are easy to construct but even less time consuming and more authentic is to wrap your design around an existing can of the same dimensions. Laminate the design with transpaseal, as has been done here, before wrapping around and securing.

have made a comeback, but the help of a construction specialist is necessary for most of these, which usually include tabs that allow parts of the image to be moved up and down or sideways. The unit cost of producing fairly complex pop-up structures is always high, and while this may not be a decisive factor in show cards for a leading product, it must be considered when choosing this type of design for other purposes. Another obvious point is that show card pop-ups should be sturdy enough to withstand being knocked over by customers and simple enough to be easily constructed from a flat pack by retailers.

Paper or board can, of course, be worked into a wide variety of forms, as the package shapes illustrated on these pages show. Although the graphic artist may only rarely be asked to design a new pack shape, it is worth noting the basic simplicity of these structures, which are all cut from a single sheet without any separate components, so making the assembly of the container very easy.

■ **Far left** These containers for frozen biscuits have a detachable lid. Interestingly, the crayon roughs on the right vary little from the finished product.

■ **Left** A small, rectangular brochure, pages of which were pasted onto thin foamcore for the client presentation, is contained in a card presentation box. This was specially designed to be given to the client's prestigious customers and to thus enhance the brochure's appearance.

SIMULATING PRODUCTS IN PAPER AND BOARD

Obviously, cylinders and cones can be shaped in paper and board. For designs for cans, aerosols and smaller objects such as pencils, markers and cosmetic products (lipsticks and eye make-up sticks), nothing could be simpler than to make a visual rough on paper or board and to wrap it around the existing object, securing it with any conventional adhesive or tape. Alternative designs can be slipped on or off at a first presentation.

SIMULATING PRODUCTS IN OTHER MATERIALS

When the container needs to be sturdy, rigid and of a certain thickness, wood, Perspex, styrene or foamcore – to which surface graphics can all be applied – are probably the most suitable materials. Foamcore is a particularly useful and versatile material because it comes in various thicknesses. It can be used as mounting board and cut and moulded in various ways to make three-dimensional models of a wide variety of products from, say, a relatively simple electric toaster to a

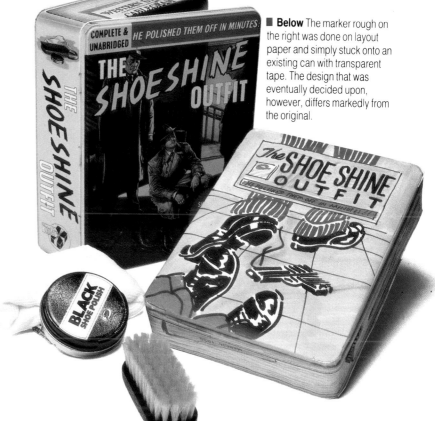

■ **Below** The marker rough on the right was done on layout paper and simply stuck onto an existing can with transparent tape. The design that was eventually decided upon, however, differs markedly from the original.

■ Constructing a transparent plastic box

1 A rough sketch of the plastic box is drawn with the dimensions worked out and indicated in pencil on the sketch.

2 The layout is now drawn accurately onto paper using parallel motion and templates to achieve the curved edges of the handle. Remember that the plan can only be drawn directly onto the acetate when *non-transparent* plastic is used, otherwise the lines will show through.

3 Position the acetate over the plan, securing it with masking tape. Score the creases using parallel motion and the back of a knife or any other blunt instrument.

4 & 5 Carefully cut out the outlines on the acetate using a scalpel and steel rule. Make sure the scalpel blade is very sharp to get a good clean cut, particularly on the curved edges of the handle.

6 & 7 Lift the acetate off the plan and with the back of a knife and steel rule reinforce the obvious creases on the acetate.

8 Carefully bend all the folds, taking particular care with the vertical folds along the sides.

9 Attach double-sided tape to the joins, peeling off the backing with a scalpel to avoid finger marks showing through on the transparent plastic.

10–12 Seal the joins firmly but gently to produce the finished box.

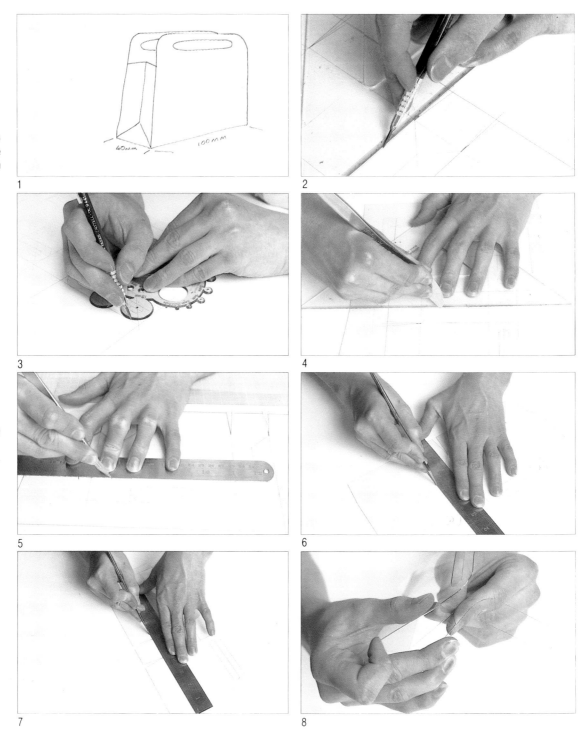

1

2

3

4

5

6

7

8

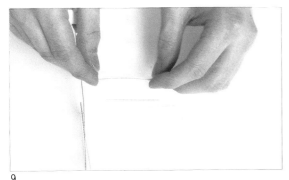

9

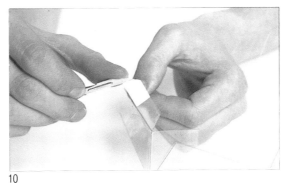

10

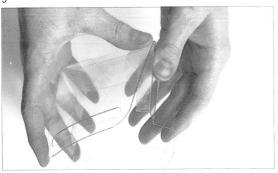

11

12

■ **Below** The plastic box was the perfect container for this paint-pack presentation. Instant lettering, tone and colour were used on the paint cans while the board heading and descriptive type is hand-rendered.

more complicated automobile design. Modelling kits are also available from art supply stores and, depending on the job, these can provide an easy way of simulating some products or parts of them.

EXHIBITIONS AND TRAVELLING DISPLAYS

Although the average designer does not routinely design exhibition stands or travelling display units, a client may approach him for help in this area. Designers who specialize in exhibition work do, of course, tackle both small and large jobs but sometimes a client feels happier with a design studio he knows, and the graphic artist then has the option of handling the work himself or collaborating with an exhibition specialist, if necessary.

Exhibition spaces are usually open or shell schemes. The designer will probably be working

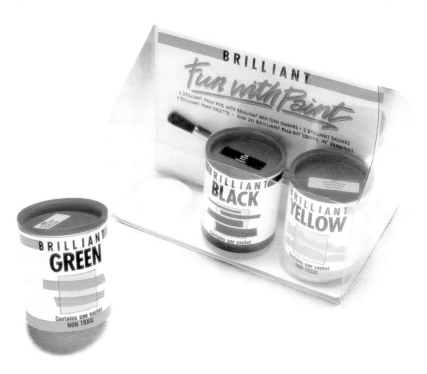

1

2

3

4

5

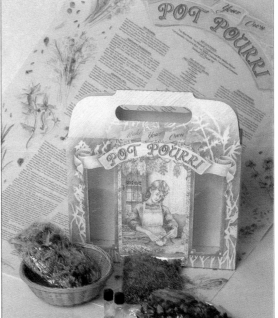

6

7

■ Making a dummy pack from a printer's proof

This pack was hand-constructed from a printer's proof because the client wanted a sample to present to his shop managers.

1 An original trace of the cutter guide was placed on the right side of the proof for correct positioning. Using the tip of a scalpel holes were pricked along the guide lines into the proof. This was then turned over and, following the holes, the cutting and folding lines were drawn up in full and the cuts made.

2 & 3 The folding lines were scored with the back of a knife. Using a metal rule the folds were then creased.

4 To cut the handles, the proof was folded to enable the artist to cut them both at the same time so they would be symmetrical.

5 & 6 The windows were then cut out and, on the wrong side of the proof, a sheet of acetate was attached over the window areas with double-sided tape before the pack was finally sealed.

7 The client thus had a dummy to show his branch managers exactly what their new product would look like before it was delivered.

Above For a pack design for sun cream products, the right pictorial image had to be first worked out. The brief specified a tropical theme. A preliminary rough (above) was adapted and a second slightly more finished rough (above right) was then used as the basis for the proposed design.

Left Alternative layouts for the pack's face were explored before the designs were decided upon. For the presentation two dummy packs were cut out. The more formal design with the framed image was applied to one and the more free cut-out design to the other. It was left to the client to express his preference.

Within the image (drawing labels):
GING BAY 1:20

PLAN 1:20 85.00mm

BIG STUFF STAND J43 IMBEX 87

PEPE UK

IMBEX 87 STAND J43

PLAN/ELEV

BST 001

■ **Left** For the design of an exhibition stand, it is usually necessary to produce a plan of the area to scale which shows the precise layout of the stand, including furniture, plants and so on. Although this gives detailed and accurate information about the space and how it will be used, it is not visually descriptive except to the trained eye. For this reason, the designer nearly always includes in the presentation a more attractive perspective drawing showing how the stand will look.

mostly with the latter, commissioned by the exhibition organizer, which consists of a basic square or rectangular structure on a raised floor, separated on the back and sides from other exhibitors but open in the front where it faces an aisle. An open space is usually more expensive to hire because it will probably be larger. It is generally on a raised platform (to provide additional services such as plumbing, if required) and, within its overall dimensions, any shape can be constructed. This certainly gives the designer more scope, but if an unorthodox, customized structure is suggested, the expense is considerable, particularly if it includes the cost of a construction specialist.

Instead of a purpose-built stand, the designer may specify a systems stand or, indeed, use a combination of the two. With a shell stand, the designer makes use of the panels that are provided and can introduce additional elements within the space allocated. However, if the budget is fairly high, proprietary structural and display systems can be incorporated on such stands.

Generally, the graphic artist is concerned with surface graphics that are combined with panel systems because this is within his or her skills. Design considerations involve both practical and creative aspects. The first question is: what image and message does the client wish to convey? The second is: how is it best to convey that image to exhibition visitors who will walk

into and around the stand?

Attention should, for example, be given to traffic flow. A radial layout is more inviting for casual visitors, whereas a boothed arrangement is more conducive to concentrated attention. Practical considerations such as the width and number of traffic areas, the need for private conference areas, furniture, lock-up cupboards, and so on must all be thought out in roughs and included in any models. Materials for flooring and walls, including wall-mounted displays, must be considered, as well as other types of display or information panels. Soft carpets, felts and similar materials – along with plants – can soften the austerity of many exhibition stands, and lighting and three-dimensional lettering can help to focus on key elements.

Like an architect, the designer should first produce presentation roughs showing plans and elevations to scale. Perspective or paraline drawings are also a help. At this stage it may not be necessary to build a scale model, but this will almost certainly be necessary for a further presentation. If the job is a large one, it is worth handing this to a professional model maker who will use the materials suggested or be able to simulate them more exactly. You can, however, make simple models yourself out of card and foam board mounted on card, foam board or a wood base. Unusual shapes can be introduced using ad hoc (found) components, and scale figures are obtainable from model shops catering for architects and amateur model makers. (Professional model makers usually work on a reduced scale of ¾ inch to one foot.) Simulate textured finishes by mounting found materials on the structural surfaces and mount wall displays, graphics and other features on the flats, before assembly.

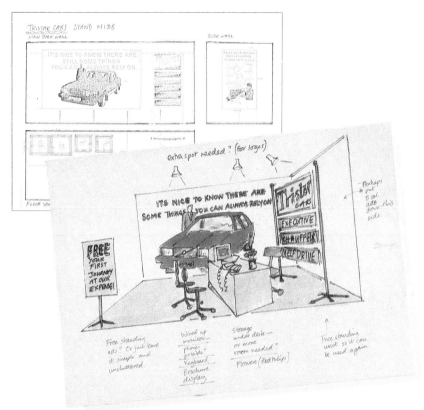

Travelling displays usually consist of a series of panels on which graphics are mounted and which can be assembled and dismantled easily. Panel systems can be bought to which visuals and other materials can be added, and these have the advantage of being functional, well made and easy to erect. The latter is a particularly important consideration because travelling displays often have to be assembled by people who have no knowledge of construction and who have never seen the display before. For presentations, roughs are usually sufficient to show the proposed design for such panels and to indicate how the panels themselves can be hinged together in various ways. If necessary, a very simple model of the arrangement of the panels can be made using paper and card.

■ **Above** The top rough gives an indication of the proposed surface graphics for the stand's wall. The simple marker rough reflects the proposed look of the stand. Detail queries annotated on the rough will be clarified with the client at presentation stage.

Finishing touches

ONCE THE VISUALS for a design have been completed, they need to be physically shown in a presentation. Some designs can simply be shown as single items – for example, a package design or any other three-dimensional object, or a book jacket. Flat items invariably benefit from being mounted, for a number of reasons. One is to enhance the visual itself, or to incorporate it into a designed presentation 'package' for, say, corporate identity. Another is for the largely practical purpose of protecting the material, including dry transfers with mounts, overlays or seals, especially when it may be handled a lot by the client or colleagues.

The decision about how the material is to be physically presented should be made fairly early on in the design process, even perhaps before doing roughs. Indeed, the actual presentation of visuals is as much an integral part of the design exercise as the visuals themselves, because how they are mounted, on what type of board or paper, and with what kind of overlay can enhance the design or detract from it. A letter-head by itself, for example, can look very insubstantial unless placed on a background that heightens the design.

What options are chosen depends largely on the client and his understanding of design. The more visually unsophisticated the client, the more 'window dressing' is appropriate when showing the visuals. This has little to do with the quality of the basic design but everything to do with the presentation of it in a way that the client feels happy with and will appreciate. Some roughs, therefore, have to be attractively dressed up before they are acceptable – beause that is what the client expects. Many inexperienced designers neglect this aspect of the presentation and can be disappointed with the lack of

■ **Left** The L-shaped mounting aid is one of the most useful pieces of equipment when trying to decide on the right mount for an image. It costs virtually nothing because it can be made out of the off-cuts from a piece of board. Make the mounts in a variety of widths and colours so that they can be placed around the image in turn and facilitate the final decision. In this case the photograph was to appear in a cookery book and the L-shapes were used to determine the most effective crop.

enthusiasm shown for even a brilliant design.

Finished roughs can be mounted on board and protected with overlays, framed with or without a window mount, contained in folders or portfolios, or sealed in various ways. There are conventional techniques for doing this and there is a wide range of proprietary aids available to make the task easy.

MOUNTING VISUALS

Picture framers have a wealth of mounting papers and will, of course, frame and mount work to high professional standards, although at a cost. Mounting layouts oneself is, however, cheaper and fairly simple. The most straight-forward method is to use a coloured cartridge paper window mount or mounting board. This is a thick type of board covered on both sides with smooth facing paper, and the most popular are black, white or grey, because these tend to show up the colours of the visuals to best advantage. There is also a wide range of coloured stock available, some with a high gloss finish that is ideal for package presentation. Recently on the market are foamcore boards which are extremely light and rigid and coated on both sides with smooth white paper. These are very easy to cut to any shape and are also frequently used for model making.

The first point to remember when mounting visuals is that when artwork is placed dead centre within its mount, it creates an optical illusion by appearing lower than its actual position. This can be corrected by mounting the artwork slightly higher than centre. It is important to cut the mount efficiently, and this is best done by

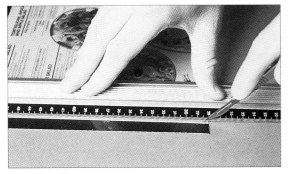

1

2

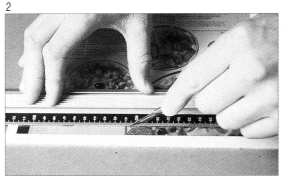

3

4

5

6

1 Flush mounting is used when a border is not necessary but extra strength and support are needed. Place the presentation onto the card and cut all around the edges, adding about 10mm to the final size. Always make sure that the trim marks are made on the right side of the presentation. Line up the trim marks and with a scalpel and metal rule make small cuts into the edges.

2 Turn the presentation to the wrong side and attach strips of double-sided tape along the edges, making sure it just covers the cuts. Remove the backing strips.

3 After matching the cuts place the presentation onto the card and press down firmly. Use a piece of tracing paper when doing this to avoid any hand marks spoiling the surface.

4 Using a metal rule and scalpel line up the trim marks and lightly cut along all the sides, just scoring the surface.

5 Work around all the edges again making several light cuts as this gives a much cleaner edge.

cutting all layers together. Unless one is using foamcore board (which can be cut with a scalpel), it is necessary to have a proper cutter or trimmer such as a guillotine or rotary trimmer, although a stanley knife can be used in combination with a metal straight edge, if nothing else is readily to hand. Special cutters are also available which produce straight or bevelled edges, and any hairlines can be removed with a scalpel.

6 & 7 Finally, run the scalpel blade along the edges to remove any loose bits of card.

7

1

2

3

4

5

6 Measure the desired border width and mark lightly with a pencil at the top and bottom of each edge. Often the bottom border is cut wider than the other edges because it looks more correct visually.
7 & 8 Repeat steps **5, 6 & 7** for flush mounting and, finally, clean up the presentation's surface.

▇ Top mounting with border

1 As for flush mounting, make the trim marks on the right side of the presentation and make small cuts into the edges.
2 Turn the presentation over to the wrong side and attach double-sided tape, but do not remove the backing.
3 Turn the back to the right side and cut along the trim marks, stopping short of the lower edge, and remove the excess border.
4 Remove the backing strips of the double-sided tape from the wrong side of the presentation.
5 Leaving a generous margin all around, press the presentation down firmly.

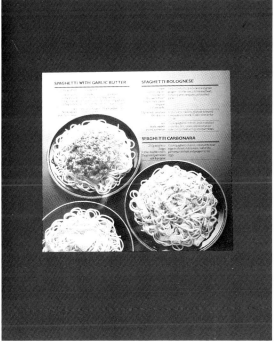

6

7

8

Spraymounting (in an aerosol can) is the most popular adhesive because it is so easy to use, particularly with visuals of irregular shape. But the atomized particles of glue are easily inhaled into the lungs, and if you use spray adhesives regularly it is worth buying a special spray shield cabinet which helps to trap the particles of glue. Alternative adhesives are rubber cement (Cow Gum) and wax, both of which, like low-tack spray glue, allow for repositioning of the artwork. Double-sided adhesive tape is another option if the board or paper is reasonably thick, although with this method it is difficult to reposition the work.

Aesthetic considerations govern the choice and colour of the mount, and thought should be given to where annotations, if any, are to be placed. Although the mounting of a single image is relatively simple, the mounting of multiple images on one board is a more complex design problem, especially if the images are of different shapes and sizes. Unless the spatial relationships are carefully worked out and the composition of the elements thought of in design terms, then the layout could look scrappy and unprofessional. If necessary, borders can be introduced to hold together images that are sequentially related.

All presentation artwork should be labelled for the obvious reason that one may be competing with other designers for the job. Experienced graphic artists make a design feature of this, selecting among the wide variety of adhesive stock available. Labels can therefore be both functional and attractive, and many designers find it worthwhile to have these specially printed up with the design studio's logo in the appropriate sizes and colours. Usually, every label should include the design company's name and address, the name of the client, the project name

1

2

3

■ **Sinking in mounting**
This is a particularly good way of presenting photographs. The prints are sunk into the card so that both surfaces are level. It not only gives a neat and very professional appearance but also prevents the corners of the print from being lifted through constant handling.

1 Cut the print to the required size using a set square and pencil to ensure accurate right angles at the corners. Take a piece of medium or heavy card the size of the print plus the border and an extra margin of approximately 10mm. Place the print onto the card and draw around the edges in pencil.

4

5

2 Soak the back of the print in lighter fuel and peel off the backing.

3 Using a metal rule and scalpel, cut along the pencil lines very carefully so that only the top layer of the card is cut. Soak this area in lighter fuel and, as in step **2**, peel away the surface. Lighter fuel is usually used for this purpose as it dissolves most adhesives.

4 Attach double-sided tape along the edges of the wrong side of the print, peel off the backing and drop the print into the surface of the card. Smooth and press firmly into place.

5 Measure the required border from the edges of the print, mark in pencil and trim.

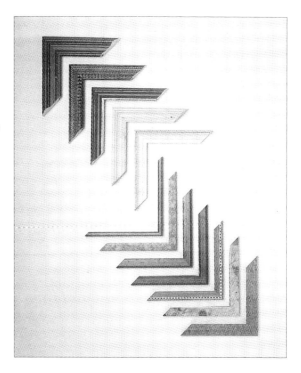

or description, and what the item is. Optional inclusions are the date of the presentation and an approval line which is signed and dated by the client; these can be positioned on the back of the artwork if space on the front is at a premium or if they appear too obtrusive.

Window mounting is a fairly simple technique which takes only a little time to master but which is often necessary when the design is a piece of commissioned artwork, or for finished presentations. However, should there be a lot of window mounting to be done, it may be cost-effective to commission the work from a professional picture framer.

The first and most important thing with window mounting is to isolate the image to be framed by using four pieces of card or board to compose the picture. Mark off the edge of the picture with a soft pencil, then follow the steps

below to cut the mount. A bevelled edge (45° angle cut) generally looks more professional. To cut a circular or oval mount, follow the steps for drawing ellipses and circles described in chapter 3. Adhesive tape is usually adequate for keeping the artwork or drawing in position within its mount, and enables the artwork to be easily removed if it needs to be changed in some way.

Without a backing, however, artwork is rather vulnerable, particularly if it is to be handled a great deal. In this case, it may need a protective cover of glass or Perspex and a wood or metal frame to hold the layers together. There are many do-it-yourself framing kits available not only at art suppliers but also in large department stores, and if these suit the purpose, they are a low-cost way of framing the visuals for protection and presentation. Both metal or wooden frames can be cut to fit, and to make the job even

■ **Above** It is not usual practice to have a presentation framed because changes to the original concept are so frequent. However, it is a good idea to hang some of your best examples around the studio to impress visiting clients. The best way to protect them permanently is to frame them and – with all the choices available – there should be no trouble in finding frames to suit any style of illustration.

1

2

3

4

5

5 Place the presentation onto the mounting board and remove the backing strip from the top edge only of the window. Match the corners with the trim marks on the presentation and press into place. The remaining backing strips are now removed and the window mount smoothed down, starting from the inner edges and working outwards.

■ Window mounting

1 A light to medium weight card, thick paper or cover paper is used for the window mount and a medium to heavy weight card for the mounting surface.

2 Place the presentation onto the two mounts and cut both surfaces at least 10mm wider around all the edges than the finished size.

3 On the wrong side of the window mount measure the area which is to be cut out and the required border width. Make small holes with a divider – or a pin will do – at all four corners. Turn to the right side and after matching the holes cut and remove the window.

4 Attach double-sided tape along the edges of the window and the outer edges of the border.

easier, clips of various kinds can be bought to hold together sheets of glass or Perspex. Proprietary box frames, suitable for framing three-dimensional objects, are also available; these usually have a depth between the back and glass of up to five centimetres. The drawbacks to these frames are that the objects must be very firmly fixed to a stiff back support, and there is a danger that humidity will cause cockling of the paper within the frame.

Many graphic artists, however, need to get their frames and covers made to measure at a picture framer's, particularly if they want something unconventional in either shape or mounting style. In this case, they must be absolutely clear and precise about what they want, because framers are used to making decisions about visually centering images, for example, unless otherwise instructed. Also specify the exact

colours and materials of mounting paper or board, if necessary.

With most framed images, the covering material is glass, which the framer will cut to fit or which you can have cut to size if you are mounting and framing yourself. If, however, the single image or multiple images occupy a large area and need to be portable, Perspex is more suitable. Although expensive when compared to glass, it is much lighter, safer and more flexible and comes in different thicknesses cut to measure.

MOUNTING TRANSPARENCIES

Black paper transparency mounts can be bought at photographic suppliers for single items of standard sizes, and in sheet form for multiple images of standard sizes. Most graphic artists use these rather than cut their own, and when attractively labelled they can look very smart as

■ **Using extra-thick board**
Extra-thick board is available for mounting. It consists of a layer of foam or polystyrene sandwiched between two sheets of thin card. Although this gives an extra-sturdy mount the edges and corners are prone to damage and will soon look untidy. To prevent this it is best to cover the board with paper.

1

1 Mark the board to the required size using a set square for the corners. When cutting this type of board hold the scalpel vertically for a clean straight cut.
2 Mark the board area on the wrong side of the paper and cut the paper, allowing a 5cm border.

2

3

4

5

6

7

3 Attach double-sided tape along the outer sides of the board and fold the tape over to the front and back.
4 Remove the backing strips and, matching the edges with the pencil marks on the paper, fold the edges of the paper over and secure with masking tape.
5 & 6 Take the edge of the paper and fold towards the opposite side of the corner.

8

9

7 Turn over to the right side and repeat.
8 & 9 Turn the paper over to the wrong side, making sure the corner is neatly folded. Attach the paper with masking tape and repeat for the other three corners. Finally, attach double-sided tape under the edges to hold the paper in place.

Cover flaps

Protect your presentation, however it is mounted, by attaching a cover flap. Any thick paper can be used, although matt is preferable because glossy or printed papers may show fingerprints and are easily scratched. It is also a good idea if the colour of the paper matches the mount or the background of the presentation. Cover flaps are attached along the top, except on very narrow presentations when it is best to attach them along the left edge.

part of a presentation. Clear plastic transparency bags with a transparent overlay are also available but, although these are adequate for working with, they lack professionalism for all but the most informal presentation.

It is not particularly difficult to mount your own transparencies, and this is clearly necessary when, for example, you wish to mask some of the transparency or when, say, you are mounting transparencies of different sizes on the same sheet. In this case, make your presentation attractive and consistent by using the same board or colour as your other artwork mounts.

1 Use paper approximately 50–100mm wider than the presentation and allow about one fifth of the size of the presentation for the top edge. Score this top edge with a metal rule and the back of a scalpel.
2 Place the presentation face down matching the top edge to the scored line. Fold the flap over and crease.
3 Attach double-sided tape to the edge of the flap and peel off the backing.
4 & 5 Reposition the presentation and press the flap down firmly.

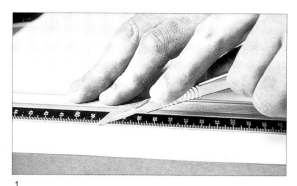

1

2

3

4

5

6

7

8

6 Place a metal rule along the edges of the presentation cover flap and, with a scalpel, trim to size.
7 Make a pencil mark 5mm from the bottom edge of the folded flap.

8 Place a metal rule on the diagonal from the top corner edge to the pencil mark and cut – making sure not to cut into the presentation – and lift the piece away carefully.

PRESENTATION FOLDERS AND PORTFOLIOS

There are many conventional portfolios available at art supply stores, and most designers will already own at least one of these. For presentation work, however, the most suitable are the stiffened display portfolios, made of synthetic or real leather, with ring binders capable of holding plastic sleeves in which visuals can be protected. These usually have an all-round zip and a hinged spine so that they can be laid flat to display artwork. More sophisticated variants are the stand-up presentation portfolios which, as well as opening flat, become free-standing angled 'easels' – a useful facility for group presentations, A number of presentation binders, folders and books are also available in a variety of colours and materials, as are the traditional tie-up card portfolios. The latter can, of course, be a do-it-yourself model, custom designed for a particular

■ **Above** Portfolios come in all shapes and sizes and this particular type is extremely practical for presentations. It is portable and can be set up on any surface, enabling the client to view the presentation easily as well as showing your work to its best advantage.

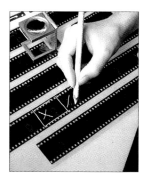

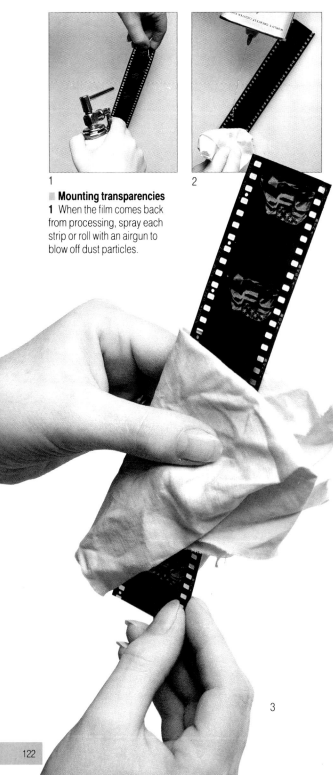

■ Mounting transparencies

1 When the film comes back from processing, spray each strip or roll with an airgun to blow off dust particles.

1

2

3

2 & 3 The film can then be cleaned with lighter fluid. Apply to the shiny side only and wipe with a fluff-free cloth. If the emulsion side needs to be cleaned, make sure the cloth has no abrasive qualities or the transparency could be irreparably damaged by scratches.

4 Slide the film strips into proprietary view packs (with an opaque backing to reflect light). Place on a light box and view with a magnifier, marking off the frames chosen with a Chinagraph pencil.

5 Remove the strips from the pack and carefully cut off the chosen frames with sharp scissors.

6 & 7 Place each transparency in a ready-made mount and seal.

8 Mounts are available in a range of sizes and materials, including card and plastic. Card mounts are sealed with an adhesive which makes the extraction of the transparency difficult (you may subsequently need to cut the mount with a scalpel). Most plastic mounts, however, are envelope-like and the transparency can be easily removed and reinserted.

4

5

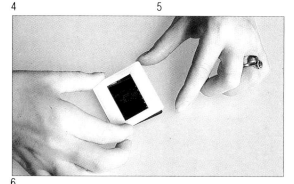

6

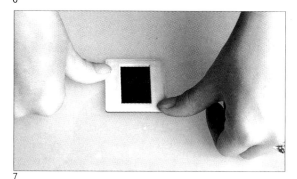

7

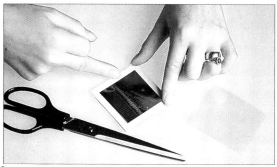

8

■ Mounting transparencies in multiples

1 Take two sheets of card of appropriate size. Measure and draw in the windows.

2 Cut the windows through both sheets at the same time using a scalpel and steel rule. Take particular care with the corners, trimming each sheet separately if necessary.

3 & 4 Separate the cards and on one card secure a sheet of opaque diffuser along the top edge with double-sided tape. This forms the backing for the transparencies.

5 On the same side of the same sheet, place a strip of double-sided tape along the horizontal borders of the windows.

6 Press the transparencies in sequence, shiny side up, onto the tape to secure and set aside.

7 Taking the second sheet of card, secure a sheet of acetate along the top edge with double-sided tape. Rub down captions onto the acetate using instant lettering or, if preferred, use a prepared acetate and hand render the captions in coloured ink.

8 Finally, secure the sheets together with double-sided tape along the top and bottom edges.

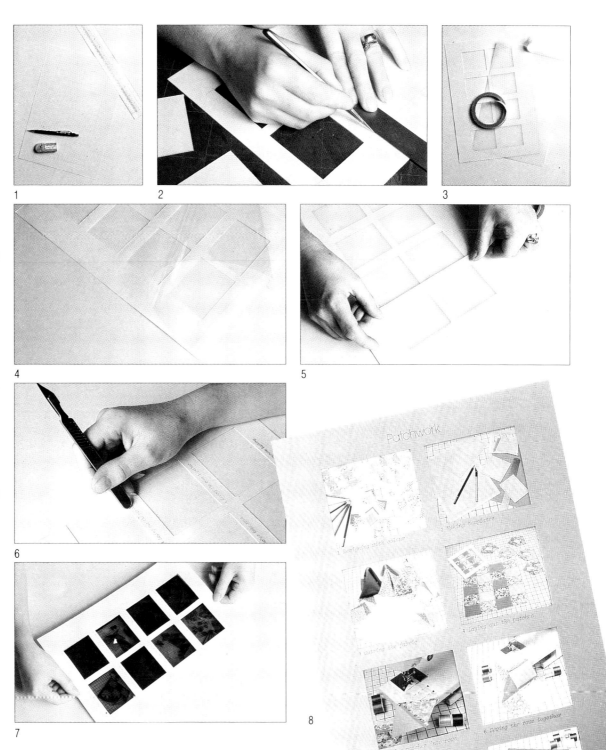

1

2

3

4

5

6

7

8

presentation and in the same colours as boards or papers for mounting visuals.

Presentation folders and books are particularly useful when the designer needs to leave material with the client. If, for example, he has used fairly large-sized mounted visuals for the presentation itself, reduced copies of the work can be slotted into such folders, thus protecting the precious originals from handling and general wear and tear.

A presentation box or container is not quite as easily produced as a portfolio, although these can be made up to specifications by specialist houses for a fee – and for a prestigious job, it is well worth it. Off-the-peg presentation boxes are available in wood but the limiting factor here is that they are produced only in conventional sizes and shapes. One therefore may be obliged to make a box oneself using card or plywood and glue, or Perspex and glue or solvent. When working with Perspex, use a solid colour so that the joints do not show.

When dealing with objects to be encased in a box, some type of mould (the shape of the object) is usually needed. This can be made from layers of plastic foam – deep frozen to make cutting easier – or from the vacuum-formed moulds commonly seen in chocolate boxes. Vacuum forming has to be done professionally from a wooden master, but it is not a particularly expensive process and is an easy way of giving a boxed object a really high-quality look.

PROTECTING VISUALS

Most presentation visuals have to stand up to a considerable amount of handling and if you have not framed or covered the artwork with glass or Perspex, you will need to protect it in some other way. Artwork in pencils or pastels (once

■ Making a folder

1 Once the work to be presented has been measured, a paper template is constructed. This is not stuck together but fitted around the visuals to make sure it is the correct size. Note how the slit which will hold the top flap has been reinforced before cutting to prevent the paper from tearing.
2 When the template is the correct size it is placed onto the back of the card and marked out in pencil.
3 Using a rule the pattern is then drawn in full.
4 & 5 The lines are then cut and the fold lines scored. Note how the rule has now changed to metal as one should not use a plastic rule with a scalpel.

1

2

3

4

5

6

7

6 & 7 Double-sided tape is placed along the edges and the folder sealed.
8 The visuals can now be left to the client with the added re-assurance that as well as looking good, your work is safely in one place and less likely to get lost.

8

immensely popular for visuals but now largely superseded by markers) needs to be fixed before it is handled in any way, to prevent smudging. Proprietary aerosol fixatives are best and should be sprayed evenly and carefully onto the drawings in a fine mist. Too much will over-saturate the illustration, dulling the colour and darkening the tone. On the most basic level, artwork can simply be protected by an overlay of white or coloured paper glued or taped to the back of the board and folded over; but if the artwork is to be handled a lot, alternative ways of protecting it should be considered.

Most designers have a general-purpose coating and fixative in their studio, and this is a useful aid for protecting both visuals and dry transfer material from smudging, grease and handling. It is not as wear-resistant as some varnishes, mostly available in aerosol form, which can be built up layer by layer to provide a matt or glossy protective finish. Some varnishes can alter colour tones so it is worth testing various types before applying one. One brand absorbs ultraviolet radiation, thereby protecting colours from yellowing and aging; and paint-on varnish is also available for coating small or difficult areas on an object.

Lamination is one of the best ways of protecting artwork. In this process, which is done by specialist houses at reasonable cost, the artwork is sealed between two sheets of clear flexible plastic. The reverse side of the artwork can also be used, if necessary, to show supplementary visuals or text matter. If mounting only one side, do not use thick board, which the lamination machine cannot cope with, but rather thin white or coloured paper. Once sealed, the artwork is protected from air and dust and does not seem to be adversely affected by ultraviolet

1

2

3

Hand laminating a book dummy cover

Low-tack self-adhesive transparent film (transpaseal) is used for this. It protects the visuals but can be removed relatively easily without damaging the surface underneath.

1 Mount the dummy cover onto cartridge paper of a chosen colour (black in this example) and attach to a cutting mat or other surface that will take cut marks. Cut the roll of self-adhesive film to the required dimensions, leaving up to 25mm all around, plus an additional 5cm to the length of the mount.

2 Peel off about 5cm of the backing paper and attach the film itself to the work surface. Using a plastic ruler, carefully and slowly smooth down the film over the artwork, gently peeling off the backing sheet as you work. Do not hurry this but work slowly to avoid air bubbles forming under the film.

3 & 4 Carefully cut around raised images with a scalpel so that air bubbles do not form, and smooth away any that do develop by pricking the film with the tip of the scalpel. Finally, trim the borders, turn the dummy cover over and fold down the film.

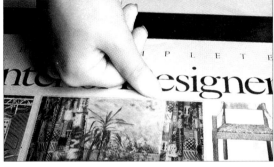

4

light. It can be wiped clean, looks slick and professional at a presentation, and temporary notes can be made on its surface (in wax crayon) if desired. However, lamination is really only suitable for final presentations because after sealing, the artwork cannot be altered in any way. Laminated work can take an infinite amount of rough handling (restaurant menus are commonly laminated!) and if your work is likely to undergo that sort of treatment, then this is the process to use.

Clear adhesive film is another alternative protection for presentation visuals. Low-tack, soft clear vinyl film (Transpaseal in the UK), gives an excellent, temporary covering to visuals which may need to be corrected or altered after the presentation. It can be cut to size and laid down, but will later peel up easily without damaging the surface underneath. Low-tack film

tends to dull the colour of visuals but on early presentations this is a small price to pay for its ease of use. Protective clear adhesive film simulates a laminated finish on artwork, but although it offers good protection against grease and general wear and tear, it is more or less permanent and is extremely difficult to remove without damaging the surface underneath.

Another removable, protective cover is acetate, a sheet of which can be lightly glued to the surface or mount of the artwork. Choose fairly thick sheet film, rather than a roll, cut to the same size as the artwork. Next cut a sheet of paper about nine millimetres smaller all round than the acetate. Lay the paper on the acetate to mask all but the border and lightly spray the border with repositioning adhesive (Spray Mount). Remove the masking paper and carefully position the acetate sheet over the artwork, pressing down to seal. Acetate can also be adhered using small pieces of double-sided tape. The disadvantage of acetate is that it tends to tear easily, so this type of protection will not have a long life. However, the advantage of acetate over self-adhesive film is that it is truely transparent and really gives depth to colours. Moreover, it looks extremely professional in a presentation and can be easily removed if the artwork needs correction. A tougher alternative, which does

not tear easily, is melamine sheet.

Heatsealing is yet another alternative for permanently protecting artwork. This is a similar process to laminating in that a thin plastic film is applied to the surface in a dry mounting press using pressure and heat. Most specialist studios do this work at relatively low cost, although it can be done at home using heatmounting tissue, a heat tacker or soldering iron, and a domestic iron. Heatsealing is not suitable for certain types of printing inks, photocopies or any type of drawing that is disturbed by heat. Marker colours are also sometimes affected by the process, so it is worth testing first before opting for this method.

Although mostly associated with framing, both glass and Perspex can give visuals a high degree of transparency coupled with stiff protection. Perspex is lighter, safer, more flexible and easier to work with than glass and artwork sandwiched between two thin sheets can be easily secured with clips.

SPECIFICATIONS AND SWATCHING

The inclusion of samples to convey colours, textures and materials to be used in the design is a very important adjunct to the presentation of roughs, and in some cases is essential to the acceptance or rejection of the design idea. The precise colours and materials used for the final job are often of special interest to clients because these are tangible things that they can assess. It is also an area often neglected by novice designers to their own detriment. If the materials for the job have not been properly researched and shown problems can occur later on.

It is stating the obvious to say that a sound knowledge of materials and manufacturing methods is essential for the package designer, and that colour consistency is a must in corporate identity. Company colours with their British Standards paint numbers and Pantone colour codes for ink and paper should be shown and stated in the presentation package. Showing how the design works on different surfaces can be difficult in the presentation situation, but if the job is an important one, it may be necessary to make up samples to show the client.

Even with as seemingly simple a material as paper, it is important for the client to approve the tactile and visual quality of the material in terms of its thickness (caliper), finish, weight, colour, watermarks and texture. Show samples of the typeface, too, as a separate element. This client approval is even more important when the design is for clothing or soft furnishings, for which swatches of fabrics or yarns are obligatory.

With some product designs, it may be necessary to show one or two actual components of the item -- for example, the stopper or screw top of a perfume bottle – and again, it is worthwhile getting these made up when the component cannot be easily simulated in roughs or if roughs might give a misleading impression. When commissioned artwork or photography is involved, it is wise to show samples of the artist's or photographer's work.

It cannot be stressed too highly how important specifications and swatching actually are in a presentation. Concern over the details of the finished job is immediately appreciated by the client and helps immeasurably to support sophisticated visuals. Depending on the job and the stage of presentation, all experienced designers integrate these considerations to a greater or lesser extent in their presentation packages.

Visual aids

■ **Below** One way of making sure that you have understood the client's brief is to produce a series of simple boards each one of which states (preferably in the client's words) aspects of the design objective, such as 'target market', 'creative guidelines' and so on. Take the client through a 'boards' presentation as soon as possible after the briefing and aim to clarify any ambiguous points.

THE VISUAL AIDS discussed in this section are those techniques that help the designer to present his or her ideas to the client in an effective way. They can be used to show the fully worked out design idea itself or to explain and explore the practical and creative processes involved in the job. Frequently, they combine both elements.

When using any of these visual aids the designer aims to achieve two things. The first is to 'sell' himself and his organization to the client by gaining his approval and confidence – that is, by proving, through examples and the style of presentation, that he or she is the right person for the particular job the client has commissioned. If the job is a complicated one involving, perhaps, corporate identity and the budget is large, the designer may well be one of a number of short-listed people or companies. Therefore, how he presents himself,

his initial ideas about the product and his track record in creative design of a similar kind are of crucial importance.

The second aim is to communicate to the client the designer's analysis of the design problem and to explore the creative processes that have been used to solve it. This setting down of the 'design concept' not only involves the client in thinking through the idea but also serves to reinforce the confidence of both client and designer that they are in accord and on the right track.

PLANNING AND 'DESIGNING' THE PRESENTATION

The presentation itself should be viewed as a design problem. This means it should be visually appealing and at the same time convey information in a lively and interesting way. A prepared

The Small Back Room
Corporate Identity

Target Market
— potential clients
 city and retail base
— existing clients
 city and retail base
— advertising and P.R. companies
— peer group

Creative Guidelines
— classic
— professional
— simple and clear
— innovative

■ **Left** For this shopfront and interior design presentation, both technical and descriptive drawings were necessary. The designer decided to mount the drawings, as well as the architectural plan, on board and to talk through each board explaining why particular design choices were made. Copies of the drawings were then given to the client to take away, study and comment on if necessary.

script combined with one of the visual aids described below are the basic components, but the content and style must be carefully planned to serve the purpose of the presentation. What visual aid is chosen is partly a matter of personal preference, but bear in mind that no two presentations are the same. Each must be geared to a specific client or a specific product. The designer must therefore be prepared to vary the presentation style and the aids used accordingly.

Even the most informal, off-the-cuff presentation needs preparation, and the first step is to define the purpose of the presentation. It may simply be to explore the design concept with the client; or it may involve the stage-by-stage graphic interpretation of an agreed design concept from rudimentary sketches through to a

number of alternative first roughs. Having established the purpose of the presentation, the designer should incorporate it into the visual presentation either as a written list of key points or, possibly, as a diagram. Each subsequent stage of the presentation should be prepared so that the script and visual materials are co-ordinated. During the actual presentation itself the designer must be ready to adopt a flexible approach. Some clients may need help in clarifying their own ideas about the purpose of the design – the designer should therefore never be afraid to ask questions about, say, the market target for the product or the character or image of the product as the client sees it.

Finally, carefully consider which visual aid is most suitable for the presentation. Take into account the stage of presentation, its degree of formality, the number of clients who will be attending, the client's visual sophistication and whether actual roughs or mock-ups are to be integrated.

PERSONAL PRESENTATION

The designer needs both confidence and a certain amount of skill to successfully carry off any presentation. At first, the occasion can seem daunting, but if the presentation has been well pre-

boards, for example – is positioned correctly in relation to the audience, and he should test that electrical or mechanical aids are not only in working order before the presentation begins, but also that they are compatible with the client's facilities and power supply.

WHITEBOARDS

Whiteboards are like blackboards in reverse, and they are available in a range of sizes. Smaller ones can be placed on an easel or shelf, whereas larger ones are usually wall-mounted in a boardroom or conference room.

Special water-based markers, which can be easily wiped away, are ideal for writing on the whiteboard's slightly glossy surface, and they convey a feeling of immediacy and informality when exploring ideas with members of staff or with the client. The key points in the design problem can, for example, be written up on the whiteboard, then discussed and revised if necessary, and thumbnail sketches and preliminary roughs can be worked through with colleagues.

The same informality can be carried over into a client presentation to help involve the client in thinking through the design. However, although such a process will give the illusion of immediacy, the client presentation should, as has been pointed out, be prepared in advance. The design concept – key points written in words, together with diagrams and drawings illustrating or

■ **Above and Left** The designer believed that the best – and most practical – method of presentation for this corporate identity was a slide show, since the design had to be seen to work in disparate ways. It also had to be shown to a group of about 10 people. Because this was a big job, the designer decided it was worthwhile to run off a dozen or so copies of the finished letterhead rough so that the client and his colleagues could view the design in a more immediate and tangible way.

pared, there will be few problems once the designer has learned to relax. It is a good idea to rehearse in front of colleagues, not only to gain confidence but also to get their reactions to the style and content of the presentation. Slickness and expert delivery are not essential, but it is crucial that the points are put across clearly and convincingly. Remember, a little humour always helps.

On a practical level, the designer must make sure that his equipment – projectors, screens or

analyzing selling or design features – should be practised beforehand. The designer does not need special artistic skills to draw the usually simple diagrams and illustrations presented at this stage, but he does need a confident, fluent drawing style that makes good use of line and colour, and a relaxed, legible writing style.

It is essential that this larger scale writing and drawing are practised on colleagues beforehand. Not only is the legibility of words important, but also the composition of all the elements on the whiteboard, because this will reflect the designer's sense of symmetry. Capital letters are easier to render than enlarged cursive handwriting, and the

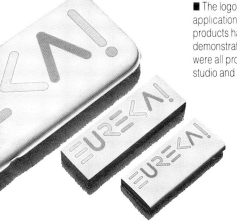

■ The logo's successful application to a wide range of products had to be demonstrated. The mock-ups were all produced in the design studio and then photographed.

designer should experiment with different thicknesses and types of marker to find those that are most effective. Once the designer is experienced and confident with his own style, he can extemporize this type of presentation at short notice.

Many designers, however, use the whiteboard as an alternative to flip charts, preparing the ideas in advance and laying them out in sequence on the whiteboard. This is a simple, fairly informal approach, the ideas rendered neatly but quite loosely, and not overworked or too rigidly presented. Such a presentation is about the design concept itself, with ideas for roughs or rudimentary roughs only being shown to the client. The advantage of the prepared whiteboard is that it leaves the designer free to talk through the creative strategy and to explain, by reference to the written words and drawings on the board, how he has interpreted the brief. The revision of written points and exploration of further graphic ideas are then all that need to be done freehand.

One practical way of managing a stage-by-stage presentation is to fix roller blinds to the whiteboard so that only one column of information is revealed at a time.

The advantage of the whiteboard presentation is its tremendous flexibility. It can be used as a giant-

sized note or sketch pad for the designer and his colleagues to work out ideas informally; it can be equally effective in a casual one-to-one client presentation or in a more structured group presentation. And because material can be so easily rubbed out and redrawn, ideas can be explored *in situ*.

FLIP CHARTS

The flip chart is the time-honoured, established way of presenting the design concept to the client. The charts may simply be a series of boards that are hand-held or placed on a stand, or they may be attached by a spiral binder or executed on drawing-paper pads and flipped over as appropriate during the presentation.

The same rules apply to flip charts as to whiteboards. They should be prepared in advance, and markers or coloured pencils are the media most commonly used. Legibility and neatness, rather than detail or finish, are the most important factors. A simple, bold approach that makes maximum use of colour and lettering works well on flip charts. Because the material cannot be erased on the spot, leave plenty of space around your words, diagrams or rough illustrations so that notes or alternative designs can be sketched in. You may need to use grid lines to get the correct size of lettering and perhaps also trace through a second piece of paper to correct word spacing. As with whiteboards, use capital letters, which are easier and quicker to draw on a larger scale, rather than your own handwriting.

Flip charts are a low cost, quick and effective way of communicating information to one person or to a group of people. One of their great advantages is that preliminary or even more finished roughs can be easily incorporated into the presentation as one or more of the charts. In fact, the beauty of flip chart presentation is that it can not only explain and explore the *approach* to the design problem but can also include the actual work itself.

OVERHEAD PROJECTION

Overhead projection (OHP) is a presentation device used by only a few graphic designers, not because it is particularly expensive, difficult to do or inflexible but because it is probably most effective when a lot of information needs to be conveyed to a relatively large group of people.

Overhead projectors accept images on acetate or film. These can be easily prepared in advance on rolls, which allow a continuous text to be wound through, or on separate sheets so that a frame-by-frame presentation can be given. The transparencies are placed on the glass-topped body of the projector, and the image is thrown onto a vertical screen. Overlay film can be added during the presentation to build up information or to explain complex processes, and alterations or additions to the visual material can be made directly onto the acetate using special OHP markers.

Most overhead projectors are compact in size, portable and offer crisp, clear images from well-produced transparencies. Most are dual purpose and come with a roll attachment as well as with cardboard frames for mounting individual transparencies. There is a vast range of proprietary material, making the actual preparation of an OHP presentation very easy. The material available includes dry-transfer lettering, numerals, graphic symbols, geometric shapes, pictograms; self-adhesive translucent film in a variety of colours and textures for laying down areas of colour or tone; as well as pre-printed sheets with boxes for charts, and grids and axes for graphs, diagrams and flow charts. Moreover, some

computer software packages can produce professional-looking diagrams and charts, which can be put onto OHP film via a laser printer. The special black and coloured markers for overhead projection are either water-based or permanent (although even permanent ink can be erased with easy-to-use solvent and cleaning tissue), and there are a choice of different nib thicknesses.

With all these aids, the preparation of overhead transparencies requires little skill and effort, and it is a shame that the technique does not lend itself more often to the needs of the average designer. It is on the whole rather too formal for most client presentations, which tend to be conducted either on a one-to-one basis or with up to six people. The technique is most useful when the job is a large, complex one, such as may be prepared for industry, where, in fact, overhead projection is widely used to explain technical processes, marketing strategies and so on. An added disadvantage is that, unlike whiteboard and flip chart presentations, actual first roughs for the job cannot be easily integrated into the presentation procedure.

SLIDE PRESENTATION

This is a favourite presentation technique with many graphic designers because of its versatility and cost-effectiveness. Essentially, the designer uses a series of 35mm colour photographs in transparency form to take the client through a step-by-step analysis of the design concept, possibly using examples from other similar projects, ideas for the design, 'word' transparencies where the key aims of the design concept are spelt out and, if appropriate, the suggested design itself.

The beauty of this type of presentation is its adaptability. It can, for example, be used to take the client through the design group's portfolio or

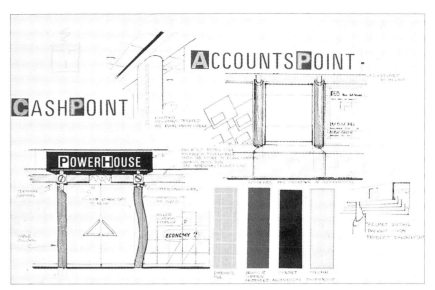

■ **Above** In this board presentation for the re-design of the consular staffrooms of an embassy, swatching in the form of sample tiles, carpet and paint colours is attached to the board itself.

to show potential clients the story of a successful design project from the written brief, through the design concept, first and later stage roughs, to the finished artwork and final product. In architecture, important visual information such as the nature of the site can be realistically shown prior to the presentation of proposed designs.

In practical terms, the carousel projector is compact and portable. Once loaded in sequence, even the time lapse between slides can be pre-set, if necessary, to linger on certain key images. The designer's task is simply to talk through the prepared presentation.

Many designers nowadays use 35mm slides as a reference system or library of all their design work, recording each project from presentation stage through to finished job. The transparencies thus form a permanent catalogue of the designer's work, which can be drawn on whenever necessary. Another considerable advantage of the slide system is that material can be printed up fairly cheaply for use in self-promotional brochures or for references for the client.

■ **Left and Right** Corporate identity presentations are particularly well suited to a slide presentation. The logo has to have the required impact in varying situations and it is necessary that these are simulated as accurately as possible. This sequence of slides focuses first on the logo itself and then on specific applications. Its effect when reduced or enlarged has to be immediate and obvious. To simulate its effect *in situ* – for example, on a lorry or in a busy street – the image was superimposed on an existing photograph and photographed in front of an appropriate backdrop.

More sophisticated than the simple carousel slide presentation is the audio-slide presentation, which comprises an extremely flexible alternative to 16mm film or video.

A pre-recorded sound tape can be attached to, and run automatically with, the carousel projection. This is clearly useful if the designer is unable personally to talk through his ideas or if music or special sound effects are to accompany the presentation. The audio-visual synchronization has to be done in special studios, so the process is expensive. However, it can be worthwhile if, for example, the job is an important or prestigious one or if the client needs to show it to *his* client or board of directors.

VIDEO AND ANIMATICS

These are not widely used by the graphic designer for presentations, except in the field of TV and cinema commercials and, occasionally, by architects. The designer of commercials will probably record his folio of work on video tape for presentation when he needs to sell his own or his company's creative achievements in this field.

Video, however, is not a suitable medium for clarifying the design concept or for working through ideas, because everything is pre-recorded and, once on tape, is fixed and inflexible. It is, however, a valuable tool for recording and showing background information that is relevant to the job. One example could be to review the

processes involved in the manufacture of automobile parts. Another could be to show the existing site of a proposed shopping complex, illustrating its proximity to amenities, access routes and so on.

Animatics can, of course, be used to good effect to enliven architectural presentations. Working on either a model or flat artwork, the video camera can simulate the effect of moving in and around the building, and create the illusion of people and objects moving on the basically still image. This, however, is the presentation of the idea itself rather than the presentation of ideas about the design, which is when most designers need to use audio-visual aids.

Glossary

Acetate A *matt* or gloss transparent sheet available in varying thicknesses. It is used for *overlays* or for the individual sheets in *animation,* on which every small change in action is recorded in a sequence of movement.

Airbrush A mechanical painting tool invented by Charles Burdick in 1893. It is a pen-shaped pressure gun propelled by compressed air. The air combined with the *medium* produces a fine spray of colour.

Altered image Referred to mainly in photography when the *image* has been changed by retouching.

Animatics A technique used in presentations that show movement. *Cut-out images* are placed loosely over the *background* so they can be moved around in different positions.

Animation A film technique in which a series of gradually changing drawings of the same subject are projected rapidly to create movement.

Annotation (1) The labelling or numbering of illustrative work. (2) Explanatory notes in the *margin* of a *text.*

Artwork Any type of *image* that is of a high enough standard to be reproduced.

Audio-slide A *slide* presentation that has been synchronized with sound.

Axial *Images* that belong to or move around an axis.

Axonometric Mainly used in architectural *illustrations* when the *oblique* has a high angle of view and the *horizontal* is given more emphasis.

Background The area farthest away from the viewer, over which the main *image* or components of it are superimposed.

Base line The guide line on which the feet of capital letters are aligned.

Bevelled edge An edge of a surface that is cut at an angle.

Binding The general term used when printed pages are secured in an outer cover. See also *Perfect binding, Plastic slide binding, Ring binding, Saddle stitching, Side stitching, Thread sewn.*

Bleed Occurs when any *medium* is applied to an unsuitable surface, causing the lines to run and blur.

Blind Refers to printing techniques that do not use ink. See also *Blind embossing* and *Die stamping.*

Blind embossing Used mainly on book covers where an impression is made without the use of inks.

Body text The main part of the written matter as opposed to the headings, etc.

Book jacket The printed sheet that wraps around the outside of a book carrying the title, author and any other information.

Brief The specifications for any job which form the starting point of a project.

Brochure An unbound, short publication with stitched pages. Mainly used to convey information and *images* for promotional purposes.

Bromide A sheet of paper with a *photosensitive* coating which is used when an *image* has to be reproduced photographically.

Bulk The relationship between the thickness and the weight of a sheet of paper.

Burnish Used mainly to describe the action of rubbing down *dry transfer sheets.*

C-type A photographic colour print which is processed directly from a *negative,* by a technique originally developed by Kodak.

Calligraphy The specialized art of creating fine *hand lettering.* The name is derived from the Greek word 'kalligraphia', meaning beautiful handwriting.

Cap height The measurement of the vertical space that runs between the top and bottom of a capital letter.

Caption The words that accompany an *illustration* or photograph to describe or explain the *image.*

Caricature A drawn *image* that purposely distorts or exaggerates specific physical features for comic or satirical reasons.

Carousel projector A projector that houses the *slides* in a circular magazine that rotates automatically, moving on to the next *image* when required.

Carton board A specific type of board used mainly in *paper engineering,* because the coated surface does not crack when folded.

Cartoon An *illustration* that translates *images* in an exaggerated or unreal way, often for comic reasons.

Cartridge paper An uncoated, all-purpose paper.

Chinagraph pencil A very soft pencil that will write on plastic, film, glass and china.

Cibachrome A photographic colour print which is taken directly from a *transparency* or flat *artwork* through a process developed by Agfa.

Coated paper Any type of paper whose surface has been given a mineral coating.

Cockle To pucker or wrinkle.

Collage The technique of building *images* by simple *cut-out* shapes or a variety of different *media,* usually pasted on a surface.

Colour separation Refers to a process in which a multi-coloured or *continuous tone artwork* is divided by photographic filtration or electronic scanners into the four process colours for reproduction.

Compressed drawing Is one in which, for example, the various manufacturing processes that a product has to

go through are shown graphically within its shape.

Continuous tone Refers to an *image* of *artwork* that holds a complete range of shades from dark to light without being broken up by dots.

Corporate identity A design that will be adopted throughout a company and used to create a continuity between their products and enable their name to be instantly recognizable.

Cover flap A sheet that is attached to the back of a piece of work and folds over to cover the front and protect it.

Cow Gum Proprietary brand of *rubber cement.*

Cross-hatching A way of creating dark, almost solid *tones* by drawing a series of small parallel lines and then crossing them in the opposite direction.

Cross-section Illustrator's view of an object showing it as if cut through to expose its internal workings or characteristics.

Cursive lettering Literally means 'joined-up writing' – the letters are formed in a fluid way without raising the pen from the surface.

Cut-away A style of *technical illustration* that shows the internal components of a complicated mechanism, such as an engine, by cutting away a portion of the outer casing.

Cut-out An *image* that has been cut away from its original *background.*

Diagram A sketch that explains something in graphic terms. See also *Cross-section, Flow chart, Pictogram.*

Die-stamping A form of printing in which the *image* is in relief on the surface either in colour or *blind.*

Dividers An instrument with two sharp points that are hinged so the distance between the points can be set to any measure. Especially useful for transferring precise dimensions from one surface to another.

Double-sided tape A roll of tape coated on both sides with adhesive. It has a protective backing strip that can be removed, enabling two surfaces to be stuck together.

Drafting pen A pen with a tubular nib that ensures a line of even width. The nibs are interchangeable and available in various sizes.

Drop capital The initial letter at the beginning of a *text* which is enlarged and descends into the lines of type below.

Dry mounting A method often used to smooth out wrinkled surfaces or reinforce *artwork.* A sheet of tissue impregnated with heat-sensitive adhesive is sandwiched between a sheet of board and the back of the surface, then pressed under force with heat.

Dry transfer sheets Printed sheets that hold letters, *images, tones,* etc., that can be transferred onto a

surface by *burnishing* the *image* on the reverse side.

Dummy A prototype that shows how a *three-dimensional* object, such as a book or package, will look by using the proposed materials but not necessarily showing all the graphics.

Dummy text Nonsense text, sometimes in Latin, used in a dummy to represent areas of text in the finished book.

Elevation Used mainly in architecture to show the *vertical projection* of a building or structure.

Ellipse A regular oval that corresponds to an *oblique* view of a circular plane.

End matter The pages at the back of a book which hold the glossary and index, etc.

Exploded view A *technical illustration* that shows the components of an object separately, but arranged to indicate their relationships within the object when assembled.

Extra-thick board See *Foamcore*.

Facsimile/Fax (abbreviation) An electronic means of sending visual material through normal telephone lines. The *image* is scanned and prints out at the receiving end.

Felt-tip airbrush A very basic but useful *airbrush* that draws its colour from a large felt-tipped pen. The results are quite crude but colour change is quick and simple.

Finished art See *Artwork*.

Finished rough See *Presentation visual*.

First proofs See *Printer's proof*.

Fixative A clear solution that is sprayed over the *image* to form a protective coating. It prevents the colour from smudging without altering the *tone*.

Flat colour Solid areas of colour without any tonal values.

Flat plan (1) A single sheet showing all the *spreads* of a book which is used to work out chapter lengths, distribution of colour and any other relevant details. (2) Also used to map out *storyboards*.

Flexography A method of printing from flexible rubber plates.

Flip chart A series of boards or sheets that are attached along the top and 'flipped' over to enable various ideas to be talked through more easily.

Flow chart A schematic *diagram* that shows a related series of events or a specific sequence.

Flush mounting Refers to mounting an *image* without any border.

Foamcore A type of mounting consisting of a sheet of foam sandwiched between two sheets of paper, which can be used for mounts or making a *dummy*.

Format The term used to describe the appearance and style of an *illustration* or page. For example, a *horizontal*

format is one in which the width is greater than the height.

Freehand image Any *image* that is drawn or cut without artificial aids.

French curves Clear plastic *templates* specifically designed to provide as many different degrees of curve as possible.

Gouache An opaque form of *watercolour* made by adding precipitated chalk to the *pigment* and then binding these components with gum arabic.

Graduated colour/tone Refers to when one colour or tone blends smoothly into another by almost imperceptible degrees.

Greeking A way of *hand rendering dummy text* that looks like an ancient Greek script.

Grid (1) In publishing it represents a double-page *spread* on which all the relevant measurements are printed. For example, the exact page size, *trim marks*, *margins*, etc. This enables the designer to position all the components of the *spread* accurately. (2) A way of *scaling* up or down by tracing the *image* and dividing it into equally-ruled boxes. The key points are then plotted and transferred onto a correspondingly larger or smaller boxed grid.

Guillotine A mechanical device used to trim sheets or boards very accurately, leaving a crisp clean edge.

Gutter The term used in imposition to describe the space for the outer edge of a book which runs parallel to the back, plus the trim.

Halftone An *image* original of *continuous tone* that has been broken down into a series of dots by a cross-ruled *screen*. The gradation of *tones* is determined by the size and density of the dots.

Hand lettering The technique of constructing letters with artificial aids and accurate measurements.

Hand rendering text Any method that represents *text* by hand as opposed to *dummy* or *Latin text*. See also *Greeking, Tramlines*.

Hatching A way of adding *tone* by a series of small parallel lines. Mainly used in *technical illustration*.

Heatsealing A very similar process to *laminating* except that only one side is sealed, which enables larger *images* to be catered for.

Highlights The lightest *tones* of an *image*, used to enhance or pin point specific features or details.

Horizontal plane Refers to the dimensions or view of the width of an *image*.

Hot-foil stamping A method of applying metallic-coloured sheets of plastic to an *image* that has been printed *blind*, through heat and pressure.

Hot-metal setting A method of setting that is becoming increasingly rare in which single pieces of type are cast

from molten metal.

Illustration (1) The term used to describe an *image* that has been drawn as opposed to photographed. (2) Any graphics or photographs that are used to explain or enhance a piece of *text*.

Image The visual subject matter of an *illustration*, design or photograph.

Image area The measured amount of space that has been allowed for a specific *image*.

In-house Any process that is carried out within a company as opposed to commissioning an outside specialist.

Instant art The term used to describe any *images* or letters that are made up from *dry transfer sheets*, pre-printed papers or any existing material.

Instant lettering positioning system A small kit that transfers *dry transfer* letters onto clear strips, which allows the letters to be moved around the *image* to see where they look best. The letters can then be *burnished* down in the usual way.

Intaglio A method of printing in which the *image* to be reproduced is lower than the surface of the *plate*.

Isometric projection A term used to describe a *three-dimensional* object or building that is drawn to scale and constructed on 30°-parallel lines. This means that the plane of projection is at equal angles to three main axes of the depicted *image*.

Justified Lines of *text* that are spaced and set to align with both the left- and right-hand *margins*.

L-shaped cropping/mounting aid Two pieces of L-shaped card that can be placed around the *image* and moved about, allowing a detail from the *image* to be selected.

Laminating Refers to an *illustration*, photograph or printed matter that is sandwiched between two sheets of transparent plastic and sealed permanently by heat and pressure. This gives a glossy protective surface that can be wiped clean.

Landscape frame/format Refers to an *image* whose dimensions are greater in width than height.

Laser printing A method of printing electrostatically used in conjunction with a computer. The *image* is created by adjusting a laser according to digital information from the computer. The *image* is then transferred to the paper by an electrostatic sub-system.

Latin body text See *Dummy text*.

Lay down The placing of all types of *media* and the components of an *image*.

Layout A *grid* that holds all the *text* and *illustrations* in their exact positions with instructions for *scaling*, etc.

Letraset A proprietary brand of *dry transfer sheets* and other graphic materials and equipment.

Letratone A type of paper made by *Letraset* that has *graduated colour* printed onto it, giving instant *backgrounds*.

Letterhead Stationery that carries the name, address, telephone number and often a *logo* or design, of a business or individual.

Light box A box with a translucent screen that forms the top and which is lit from below, inside the box. It is used mainly for viewing *transparencies*.

Line illustration An *image* that is rendered in one colour with no intermediary *tones*.

Lithography A method of printing that is based on the principle of the mutual repulsion of oil and water. Both the *image* and non-image areas are on the same plane so the paper comes into contact with the whole plate surface. The *image* area is treated to accept a grease-based ink and the non-image area to attract water.

Logo Usually a word or letters cast as one unit for a trademark or company signature.

Low-tack adhesive An adhesive that is not permanent and is used mainly to secure items that have to be moved around or removed altogether at a later stage. See also *Cow Gum, Masking tape, Rubber cement, Spraymount, Wax.*

Margin The blank areas at the edges of a page that surround all the printed matter.

Markers Usually refers to the broad, felt-tipped pens used for *presentation visuals* but more generally to any coloured felt-tipped pen.

Mask Any type of material that is used to block out specific areas of an *image*.

Masking tape A tape coated on one side with a *low-tack adhesive*. It can be used as a *mask* and for attaching loose matter to *layouts* because it can be peeled off without damaging the surface.

Masthead Usually refers to the name of a newspaper or title of a book that appears at the top of the front or editorial page.

Matt surface Strictly speaking a paper that has a dull, eggshell finish and that is usually clay-coated. However, the term is used more loosely to describe any paper – including uncoated – that does not have a glossy finish.

Mecanorma Proprietary brand of *dry transfer sheets*.

Media/Medium Refers to any type of colouring agent – ink, paint, dye, etc. – that is used to cover a surface.

Mezzotint A process used in *intaglio* printing that produces a range of *tones*.

Mock-up A rough visualization of a design showing its size, colour and composition.

Mounting A general term referring to various methods of presenting visuals using a backing sheet of card or board and a protective *overlay*. See also *Flush mounting, Multiple mounting, Sinking in mounting, Top mounting, Window mounting.*

Multiple mounting Refers to when more than one *image* is mounted on a single sheet.

Negative Photographic film that has been processed to fix a reverse *tone* or colour *image*, from which a positive print can be taken.

Oblique A line that slants or declines at an angle from the *vertical* or *horizontal*.

Omnicrom The brand name of a machine that colours designs that refers to the process. The *image* that is to be coloured has to be photocopied because it is only this type of black ink that the machine will pick up. The photocopy is sandwiched between a transfer sheet of the chosen colour with a paper backing. This is then fed into the machine and passes through rollers that apply pressure and heat. The transfer sheet is subsequently peeled off, leaving the black photocopied *image* coloured.

Origination This term describes all the preparatory stages for printing before actual reproduction begins.

Orthographic projection Mainly used by architects to show a flat view of an object or building. A scale drawing is made to show all the different aspects, with precise information and measurements included so that the object or building can be accurately constructed.

Overhead projector/OHP (abbreviation) This projects *images* that are drawn on a transparent *acetate* slide or roll that passes through an overhead lens, turning the *image* through 90° onto a flat surface.

Overlay (1) Any type of translucent sheet that is placed over an *image* as protection or on which instructions and corrections can be recorded. (2) A transparent sheet used in the preparation of multicolour *artwork*.

Packaging A pack that is constructed and designed for an individual product.

Pantone The brand name of an internationally recognized colour matching system that is standardized throughout the complete range of designers' materials.

Paper engineering Although this refers to the basic construction of *packaging*, it is widely used for the more complicated techniques employed for *three-dimensional* structures.

Paraline drawing A general term used to describe any drawing that is constructed on parallel lines.

Parallel motion A specific type of drawing board that has counterweights and a straight edge to ensure completely accurate positioning and measurements.

Paste-up A term used to describe any job involving several components that have to be positioned. For example, a page *layout* or advertisement.

Perfect binding The method of *binding* most commonly used for magazines and paperbacks in which the pages are trimmed and glued, not sewn.

Perspective drawing The most widely used form of *illustration*. There are no optical distortions and it shows reality as we perceive it with the naked eye.

Perspex A transparent sheet that is made from acrylic thermoplastic and that is much lighter than glass as well as being tough and unsplinterable.

Photocopy An instant way of copying an original by various photographic techniques. Although useful for presentations the quality is not good enough to be reproduced from.

Photomontage When *images* are taken from several different photographs or *transparencies* to produce a single composite *image*.

Photosensitive A surface which has been treated chemically making it sensitive to light.

Photosetting A form of *typesetting* that is photographically produced onto film or *bromide*. The quality is good enough to be reproduced from directly and its versatility is endless.

Pictogram A pictorial sign or symbol.

Pigment The substance, whether mineral, vegetable or synthetic, that is the colouring agent for all *media*.

Pinholing A method of *blind* printing that depicts lettering or designs by using a series of small pinholes.

Plastic slide binder A plastic gripper that slides over the spine of printed matter to hold the cover and pages together.

Portfolio A case available in varying sizes to carry around presentations or *artwork*, keeping it flat.

Presentation visual Any graphic material or *illustrations* that are executed for the purpose of showing the client what the proposed design or finished product will look like.

Printer's proof The initial sheets that are printed prior to the actual print run. This enables the printer and designer to make any adjustments to the colour or tone.

Propellant Any source of air used to power an *airbrush*.

R-type A photographic process developed by Kodak which produces colour prints directly from an *artwork* or *transparency*.

Rapidograph A proprietary brand of *drafting pen*.

Registration marks The marks that are carried on *artworks, overlays*, films etc., to ensure that the *image* can be repositioned and is in register when superimposed during reproduction.

Ring binding A form of ready-made *binding* which enables the pages to lie flat. They are available with as many rings as required which are riveted to a stiff or soft cover. The rings are sprung open and sheets with holes in the appropriate places can be inserted.

Rough The initial sketches that are made prior to the *artwork*. See also *Presentation visual*.

Rubber cement A rubber-based, *low-tack adhesive* that does not give a permanent bond, thereby allowing components to be repositioned. Mainly used for *paste-up*.

Rubber stamp A device that has a raised *image* cut out of rubber – in reverse – so that it can be inked and imprinted onto a surface.

Rubdown A *dry transfer sheet* that has been produced as a one-off from an original design.

Saddle stitching A method of *binding* commonly used for brochures or smaller publications where a continuous wire is cut to form staples of the required length and inserted through the fold of the spine while the pages are supported over a saddle.

Scaling To work out the amount of reduction or enlargement necessary to fit an *image* into an alloted space.

Scalpel A cutting instrument with a metal handle that holds an extremely sharp replaceable blade.

Score To crease the fold lines with a blunt instrument and straight edge when constructing a *three-dimensional* object.

Screen The glass sheet that is cross-ruled and breaks down a *continuous tone image* into dots for *halftone* reproduction.

Shading To add *tone* to an *image*.

Side stitching A method of binding in which thread or wire is stitched mechanically through the side of the pages from front to back.

Signature The letter at the bottom edge of the first page of each section in a book, running in alphabetical order, which serves as a guide to the binder.

Silk screen A method of printing in which the *image* is reproduced by a *stencil* which is prepared by hand or photographically on a screen or mesh. The ink is then forced through the screen and onto the surface. This technique is extremely useful because it can be used on any type of material.

Sinking in mounting A method of *mounting* usually used for photographs, where the *image area* is cut out of the top layer of the mount so the *image* can be 'dropped in', making both surfaces level.

Slide A mounted *transparency*.

Software Refers to the various programs available for computers.

Spraymount A *low-tack adhesive* in an aerosol can which is particularly useful when placing small components.

Spread A term that refers to two facing pages in a publication (also called double-page spread).

Stencil A sheet from which *images* have been cut. The *images* are then reproduced by painting or drawing through the holes.

Stipple A technique used to create texture by a series of tiny dots applied by hand.

Storyboard Used to show how a filmed sequence will look by using a series of *illustrations* rather like a comic strip.

Strike-on system A sophisticated electric *typewriter* with interchangeable heads that produce various *typefaces*. It is not as versatile as conventional *typesetting* but the quality is good enough to reproduce from.

Sub-head A heading used to break up a chapter or page in a publication.

Swatch A colour specimen to which *media* and other materials can be matched.

Synopsis A condensed version of the content of a book.

Technical illustration A highly specialized type of *illustration* which shows mechanical objects or systems and their internal workings in a completely accurate way. See also *Cut-away, Exploded view*.

Templates A shape or sheet with cut-out forms and designs, used as a drawing aid.

Text The main body of written matter in a publication.

Thermography A printing process that imitates *die stamping*. The raised *image* is produced by using very thick, sticky ink which is dusted with a fine powder before being heated to fuse it to the paper.

Thread sewn A binding method where threads are inserted through each section by a sewing machine before they are sewn together.

Three-dimensional/3-D (abbreviation) An object which has depth as well as height and width.

Thumbnail sketches Very rough, small and quick initial sketches that are used to work out an idea.

Tone The varying shades of a single colour.

Top mounting A way of *mounting* an *image* so that it lies on top of the mounting board.

Tracing A drawing produced by placing a transparent sheet over an *image* and following the outline in pencil or pen.

Tracing paper A translucent paper that can be placed over an *image* so it can still be seen clearly, enabling the outline to be followed in pencil or pen.

Tramlines A way of indicating *text* by drawing parallel lines to the same width as the *x height* of the chosen *typeface*.

Transparency A photographically produced positive *image* on transparent film.

Transpaseal A low-tack, clear vinyl film with a protective backing.

Trim marks Marks which are made on a sheet to indicate where the pages can be cut and trimmed.

Typeface A general term used to describe all the various styles of lettering available in *typesetting*.

Typesetting To assemble type for printing by hand, machine or photographic techniques. See also *Hot-metal setting, Photosetting, Strike-on system*.

Typewriter A machine which produces writing usually with a fixed *typeface* and although adequate for everyday use the standard of manual typewriter text is not high enough for reproduction.

Typography The art, general design and appearance of printed matter using type.

Unjustified Lines of type that are aligned only to one margin and do not always fill out the full measure of the line.

Vertical projection The view of an *image* from top to bottom.

View pack A plastic sheet that has rows of pockets to hold transparencies. This can be placed directly onto a *light box* allowing the *transparencies* to be viewed without being first removed.

Visualize To translate an idea into graphic terms.

Wash A watercolour or ink that has been diluted so that when it is spread over a surface it is very transparent.

Watercolour A coloured *medium* that is mixed with water and has a transparent quality.

Water-soluble crayon A type of coloured pencil that can be mixed with water, and which is especially good for simulating *watercolour* quickly.

Wax A *low-tack adhesive*; in graphic design this is contained in a machine that heats the wax and applies it.

Whiteboards Similar in principle to blackboards but white with a glossy surface. Water-based *markers* are used because they can easily be wiped off.

Window mounting A form of *mounting* where the *image* is *top mounted* and then a cardboard frame is placed over the top of this to create a raised border.

Work up To add to and develop an initial sketch or drawing to produce the desired effect.

X height The height of letters without ascenders or descenders.

Index

Acknowledgements

pp6-7 *middle* Minale Tattersfield & Partners Ltd. **p7** *top* G. Dumbar for The Design Press. **p8** Moira Clinch. **p9** *middle and top* Chermayeff & Geismar Associates; *bottom right* Trickett & Webb Ltd. **p11** QDOS. **pp12-14** Trickett & Webb Ltd. **p15** Quarto Concept. **p16** *left* Robinson Lambie-Nairn. **p17** *bottom* QED. **p18** Pirtle Design. **p19** Robinson Lambie-Nairn. **p22** *top* Chermayeff & Geismar Associates; *bottom* Pirtle Design. **p24** *top* Clive Allcock-Bowden. **p25** Clive Allcock-Bowden. **p28** *top right* Tricket & Webb Ltd; *bottom* Ehrenstrahle & Co. Ltd. **p29** Pirtle Design. **pp44-45** Richard Beards for A La Carte Magazine. **p46** Helen Charlton. **p52** *top and bottom right* Robinson Lambie-Nairn; *bottom left* Joe Lawrence. **p53** *left* Joe Lawrence for K.M.P; *right and bottom* Robinson Lambie-Nairn. **p54** *top* John Gorham for Watney Mann & Truman Brewers; *bottom* The Yellow Pencil Company. **p55** Ehrenstrahle & Co Ltd. **p56** *bottom* Clare Melinsky/Lock Petterson for Barclays Bank North-Western District. **p57** Hugh Marshall for Asta Advertising Ltd. **p58** Douglas Ingram. **p59** *bottom left* Quarto Concept; *top and right* Richard Beards/the Clockwork Studio for the English Tourist Board. **p60** Richard Beards/C.Y.B. for *Farmer's Weekly*. **p61** Douglas Ingram. **p62** *top* Quarto Concept; *bottom left* Moira Clinch; *bottom right* QDOS. **p63** *top* The Design Clinic. **p65** Peter Clark. **p66** *middle* QDOS; *bottom* Trickett & Webb Ltd. **p67** *bottom* The Design Clinic. **pp 68-69** Mick Hill. **p70** Joe Lawrence/Business Address Limited for Avdel. **p71** *top* The Yellow Pencil Company; *bottom* Chartwell Products. **p72** *top* David Critchlow Architects. **p73** Stephen Wilson. **p75** Rita Wuethrich. **p76** *left* Rita Wuethrich. **p77** Clive Allock-Bowden. **pp78-81** Bob Cocker. **p82** *top* QDOS; *bottom* Trickett & Webb Ltd. **p83** QDOS. **p84** *top left* Pirtle Design; *top right* QDOS; *middle* Helen Charlton. **p85** *left* Penguin Books Ltd; *right* Sue Wilks. **p86** Agfa Gevaert Ltd. **p87** *left* Moira Clinch. **p88** Mick Hill. **p89** *right* Richard Beards/C.Y.B. for *Farmer's Weekly*. **p90** Mick Hill. **p91** *top left* QDOS; *top right* Chermayeff & Geismar Associates. **p94** Rita Wuethrich. **p99** *top* Paulette Harrison Printers. **p102** Quarto Concept. **p103** Brown, Wells and Jacobs Ltd. **p104** *top* Quarto Concept. **p105** Trickett & Webb Ltd. **p107** *bottom* Quarto Concept. **p108** Quarto Concept. **p109** Peter Windett. **pp110-111** Indicator Design Consultants. **p112** The Design Clinic. **p120** *bottom left* Rita Wuethrich. **p128** The Small Back Room Ltd. **p129** Indicator Design Consultants. **pp130-131** Mervyn Kurlansky/Pentagram Design Ltd. **p133** Indicator Design Consultants. **pp134-135** Mervyn Kurlansky/Pentagram Design Ltd.